REMARKABLE

WOMEN

of

SAN

DIEGO

REMARKABLE
WOMEN
of
SAN
DIEGO

PIONEERS, VISIONARIES AND INNOVATORS

*Hannah S. Cohen
and Gloria G. Harris*

THE
History
PRESS

Published by The History Press
Charleston, SC
www.historypress.net

Copyright © 2016 by Hannah S. Cohen and Gloria G. Harris

Back cover, bottom: From the San Diego History Center.

First published 2016

Manufactured in the United States

ISBN 978.1.46711.826.2

Library of Congress Control Number: 2016939303

BOOK TALK AND AUTHOR SIGNING

Dr. Gloria Harris

on her book

Remarkable Women of San Diego: Pioneers, Visionaries, and Innovators

Saturday April 26th 2pm

**Mary Hollis Clark Conference Center
@ New Central Library
330 Park Blvd San Diego, 92101**

LIBRARY SHOP

Hannah Cohen

I dedicate this book to my parents, Evelyn and Max Cohen, who taught me to never think you have to lose to a man because you are a woman. Put your mind to it, and you can win over anyone. I am forever thankful to them.

And to my lovely daughters, Sheryl, Laurie and Robbie, who allowed me to be me. I thank them for enriching my life and for becoming beautiful productive women and perfect mothers.

And to my husband, Elliott, who has had to endure my independent feminist streak. He was always there encouraging me and giving me the freedom to follow the paths I chose to pursue.

Thank you to my beautiful family.

Gloria G. Harris

I dedicate this book to my father, Theodore Greenfield (1902–1986), for his encouragement and my mother, Claire Greenfield (1905–1992), for her support; my sons, Cameron and Merrill; and my husband, Jay, who has given friendship and love for fifty-two years.

CONTENTS

CONTENTS

ACKNOWLEDGEMENTS

Researching and writing about these twenty-eight inspiring women who have made significant contributions to the history and culture of San Diego and beyond has been a pleasure. We want to thank the many people, both men and women, who provided us with encouragement and assistance, and we are especially appreciative of those women who agreed to be interviewed personally or via e-mail and shared their life experiences, struggles and achievements. We would be remiss not to express gratitude to those who previously chronicled our county's history in the *Journal of San Diego History*, the *San Diego Union-Tribune* and many other newspapers, books and magazines.

Sincere thanks go to Gabe Selak, public programs manager of the San Diego History Center, for suggesting many remarkable women to include in our book and to Carol Myers, photo archivist with the San Diego History Center Research Library, who assisted us in identifying appropriate images to accompany the women's stories. Our talented image consultant, Elizabeth Lee, competently sized and organized our book's thirty-two images. Ashley Gardner, executive director of the Women's Museum of California, and Anne Hoiberg, past president of the Women's Museum, made valuable suggestions and affirmed the importance of our project.

Last and not least, a special thanks go to Megan Laddusaw, our commissioning editor at The History Press for the invitation to coauthor a follow-up book to *Women Trailblazers of California* and her help and encouragement in shaping *Remarkable Women of San Diego*.

PART 1

1850–1900

When California became a state in 1850, San Diego's population was primarily limited to the Old Town area that had developed at the base of Presidio Hill. In 1865, Mary Chase Walker, the city's first schoolteacher, began teaching at the Mason Street School in Old Town, which she described as an isolated frontier town and dingy settlement. When she invited an African American woman she had befriended to dine with her, Walker became the center of controversy. As a result, school enrollment plunged, and she resigned. Walker later married the president of the school board and worked to help the needy.

After Mexican independence from Spain, the twenty-one missions established by Franciscan missionaries in California were dissolved. The Mexican government provided for resident Indians to continue to occupy their lands, but after the Mexican-American War ended, their land claims were disregarded. Incensed by the injustice, Helen Hunt Jackson wrote two books that called attention to the dispossession and mistreatment of the Mission Indians. Her novel *Ramona* attracted considerable attention to her cause and contributed to the growth of tourism in Southern California.

In 1867, San Francisco businessman and real estate investor Alonzo Horton arrived and eventually became the founder of modern San Diego. He acquired 960 acres of waterfront land, built a new wharf and erected buildings. In 1889, his third wife, Sarah, died in a carriage accident, and a year and a half later, Horton, at the age of seventy-seven, married Lydia Knapp, aged forty-seven. She played a vital part in the city's development

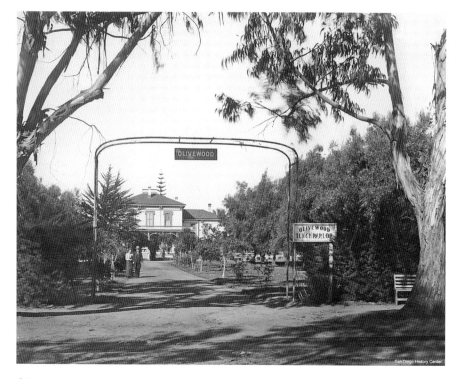

Olivewood. *Courtesy of the San Diego History Center.*

and became active in cultural activities and art circles. Her accomplishments and service to San Diego included support of women's clubs and advocacy for building the first San Diego Public Library.

In 1879, Frank Kimball, a founder of National City, traveled to Boston, met with the president of the Santa Fe Railroad and successfully convinced him to bring the railroad to Southern California. Frank and his brother, Warren, built a wharf, constructed roads and planted orchards in National City, and Warren's wife, Flora, became a noted writer and champion of women's rights. Flora was also a noted horticulturist and surrounded her home, named Olivewood, with olive, orange and lemon groves; rare plants; and ever-blooming flowers. The beauty of Olivewood's extensive gardens was frequently described in local and national publications.

Although the California women's movement began in San Francisco, interest arose in San Diego when Susan B. Anthony and her associate Anna Howard Shaw spoke to a full house at the First Methodist Church in June 1895. Dr. Charlotte Baker, president of the Equal Suffrage Association, and

Mrs. R.C. Allen, the organization's corresponding secretary, spearheaded the San Diego Women's Vote Amendment campaign. In addition to being a noted suffragist, Dr. Baker became the first female physician to practice medicine in San Diego and the first female president of the San Diego County Medical Society.

Katherine Olivia Sessions came to San Diego in 1883 from San Francisco. After leasing land that would eventually become Balboa Park, then known as "City Park," Sessions began planting trees—nearly one hundred per year in the park—and furnished three hundred more for planting throughout the city. Sessions was one of California's first environmentalists and became known as the "Mother of Balboa Park," the vast 1,400-acre park in the center of San Diego.

The women highlighted in this era did not fit into the popular image that placed women on a pedestal in late-nineteenth-century America. Middle-class white women were supposed to remain separated from the economic sphere that men occupied outside the home; home was a woman's proper sphere of influence. Few women had the same opportunities for education, and they were denied the right to vote. Moral superiority and motherhood rounded out the expectations supporting the image of the Victorian woman and her responsibilities. The following six remarkable women whose stories we recount exemplified what women could achieve in spite of, or within, a confining culture.

Mary Chase Walker Morse (1828–1899)

San Diego's First Teacher

Born in Massachusetts, even as a child Mary Chase Walker wanted to be a teacher, and by the age of fifteen, she was already teaching her own classes. After her salary was slashed due to the Civil War, she decided to seek employment in California. In 1865, Walker took a four-month steamship voyage from New York to San Francisco. When she arrived in the city, no teaching jobs were available, and she gladly accepted a position in San Diego. During her trip down the coast by ship, Walker experienced a severe bout of seasickness and was aided by a compassionate stewardess.

When she arrived in San Diego on the morning of July 5, 1865, the isolated frontier town was a dingy settlement. According to her description

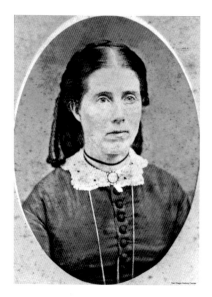

Mary Chase Walker Morse (1828–1899), San Diego's first teacher. *Courtesy of the San Diego History Center.*

written in 1898: "It was a most desolate looking landscape. The hills were brown and barren; not a tree or a green thing was to be seen. Of all the dilapidated miserable looking places I had ever seen, this was the worst. The buildings were nearly all of adobe, one story in height, with no chimneys." Walker vividly recalled her experience on the first night at her hotel. "A donkey came under my window and saluted me with an unearthly bray. I wondered if some wild animal had escaped a menagerie and was prowling around Old Town. The fleas were plentiful and hungry. Mosquitoes were also in attendance."

The newly constructed Mason Street School was located in Old Town and is still there today. Walker's students ranged from four to seventeen years of age, and all eight grades were taught in one room. Heat was supplied by an iron stove, and the indoor plumbing consisted of a water bucket and dipper. Walker concentrated on teaching reading, spelling, arithmetic and writing. Since paper was scarce and expensive, the students did their lessons on slates. In addition to a few English and several Americans, the majority of her students were of Spanish and "half-breed" origin. The latter were the offspring of American soldiers and sailors who had come to San Diego in the early days and married local women. Tardiness and absenteeism were frequent problems. Walker later recalled, "At recess the Spanish girls smoked cigaritas [*sic*] and the boys amused themselves by lassoing pigs, hens, etc. The Spanish children were very irregular in their attendance at school on account of so many fiestas and amusements of various kinds. For a week before a bull fight, the boys were more or less absent."

Walker taught for eleven months in the Mason Street School before becoming the center of controversy. According to historian Henry Schwartz, author of an article titled "The Walker Incident," she was walking on Juan Street when she recognized the stewardess, a woman of mixed race, who had cared for her during her illness aboard the steamer from San Francisco to San Diego. Grateful for the stewardess's previous

kindness, Walker invited the woman to join her for lunch at the nearby Franklin House. When they entered the dining room, several diners actually got up from their seats and left. Some of those who remained later complained to the San Diego School Board.

Raised in abolitionist Massachusetts, Walker was unaware of racial prejudice in 1866 San Diego. Most of the city's residents had migrated from southern states, where socializing with a black person was viewed as unacceptable. An article published in the *San Francisco Bulletin* explained the situation: "You see, we are high toned people down here and don't intend to tolerate anything of that kind." The fault with the stewardess, wrote the reporter, was that she was "a lady of respectability and education, but who has unfortunately a bit of negro blood in her veins."

Upset that a white woman, especially a teacher, would openly associate with a black person, parents of children in Miss Walker's class demanded that the school trustees take action. Many who viewed the teacher's behavior as improper kept their children out of school. Walker's "Teacher's Report" noted that of the thirty-six students enrolled in May 1866, two had newly entered, and twenty dropped out. The parents' boycott had nearly emptied Miss Walker's classroom.

The three school board trustees were divided about had to handle the situation. One trustee expressed concern about wasting tax payers' money and questioned why Walker should be paid to teach only a few children. He felt strongly that school money should not be wasted and recommended that Walker be replaced by a teacher who would be acceptable to the community. A second trustee, Robert D. Israel, angrily disagreed with this reasoning. He was quoted as stating, "I'll be damned if I wouldn't take that school money and throw it in the bay as far as I could send it, before I would dismiss the teacher to please those copperheads." Captain Israel made it clear that he would never consent to Walker's dismissal. As a result of the conflict, the final decision was left to senior school trustee, Ephraim Morse. A soft-spoken man, Morse owned a general store and was concerned by the potential negative effect of an unpopular decision on his business. Although he, too, was worried about the school's dipping enrollment, he also sympathized with Walker. Due to the lack of a San Diego newspaper and destruction of many of the school board records, Morse's final decision is unknown. Although the evidence is inconclusive, historians agree that Walker resigned her position and was replaced later that year by a new teacher from San Francisco.

Ephraim Morse had become enamored of Walker, and he soon proposed. She accepted, and they were married on December 20, 1866. Morse became

a successful merchant who continued to be involved in virtually every major business or civic venture in San Diego, from banks to Balboa Park and subdividing El Cajón. After her teaching career ended, Walker supported the suffrage movement and worked to help the needy. In 1898, a year before her death, she wrote her first impressions of San Diego and her students in a paper titled "Recollections of Early Times in San Diego."

HELEN HUNT JACKSON (1830–1885)

Author and Indian Rights Advocate

Helen Hunt Jackson was a poet, novelist and short story writer who advocated for Native American rights. Her nonfiction book *A Century of Dishonor* documented the histories of seven different tribes and was written in an attempt to change government policy. Hoping to awaken the conscience of the American people and their representatives to the oppression of tribal communities, she sent a copy of her book to every member of Congress with the following admonition printed on the cover: "Look upon your hands: they are stained, with the blood of your relations." Her historical novel *Ramona* was both a political and literary success that has contributed significantly to Southern California's heritage.

Jackson was born in Amherst, Massachusetts. Orphaned as a teenager, she was later raised by an aunt. In 1882, she married U.S. Army captain Edward Bissell Hunt, and they had two sons. Her firstborn died when he was an infant, and her second son later died of diphtheria. After her husband was killed in a military accident, she married William Sharpless Jackson, a wealthy Colorado banker and railroad executive. Although she previously had published children's stories, novels and essays under the pseudonym H.H.H., after her marriage, she wrote under her husband's name, Jackson.

Her interest in the mistreatment of Native Americans began in 1879 after hearing a lecture by Chief Standing Bear, who described the suffering and forced removal of the Ponca Indians from their Nebraska reservation and transfer to a reservation in Oklahoma. Incensed by what she heard, Jackson became an activist on behalf of the Poncas. She circulated petitions, raised money and wrote letters to the *New York Times* detailing the inhumane treatment of the Ponca people. Her first book, *A Century of Honor* (1881), called for a significant reform in government

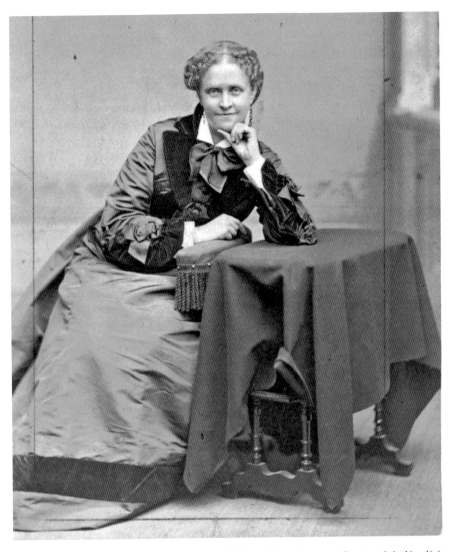

Helen Hunt Jackson (1830–1885), author and Indian rights advocate. *Courtesy of the New York Public Library.*

policy toward Native Americans. Although Congress was less than enthusiastic about her book, a presidential commission appointed to investigate the Ponca's situation led to compensation to the tribe for losses sustained during their removal.

In the fall of 1881, Jackson received an assignment from a local magazine to write articles about California. Her articles described the history of

Southern California as "a record of shameful fraud and pillage" of the Mission Indians. The following year, Jackson traveled to Southern California to begin an in-depth study. According to historian Valerie Sherer Mathes, "When Americans assumed control, they ignored Indian claims to lands which led to their mass dispossessions. In 1852, there were an estimated 15,000 Mission Indians in Southern California, but because of the adverse impact of dispossessions by Americans, they numbered less than 4,000 by the time of Helen's visit."

Undaunted by the lack of support from Congress, Jackson decided to write a novel that would depict the Indian experience "in a way to move people's hearts." She explained, "People will read a novel when they will not read serious books." She was inspired by another novel, *Uncle Tom's Cabin*, which brought wide attention to the slavery issue. "If I can do one hundredth part for the Indian that Mrs. Stowe did for the Negro, I will be thankful," she wrote. In 1884, she published *Ramona*, a romantic novel that dramatized the plight of Southern California's dispossessed Mission Indians and the brutal intrusion of white settlers.

According to historian Iris Engstrand, Jackson arrived in San Diego in 1883 to gather material for her book. She made friends with the sponsor of an Indian school, Father Antonio Ubach, who had moved to New Town and established St. Joseph's Catholic Church. He became the model for Father Gaspara, a fictional priest in her book. In an article published in the *San Diego Union* of June 25, 1905, Ubach told the reporter, "Although it took place forty years ago, I remember it very well—how the couple came to me and asked me to marry them. But it was not in the long adobe building which everybody points out as the place—that is the Estudillo place—but it took place in the little church which stands not far away." Although he was well acquainted with the book's main characters, Alessandro and Ramona, Ubach stated "those were not their real names. I know what their right names were, but I do not care to tell. Mrs. Jackson suppressed them because she did not care to subject the families to the notoriety that they would be sure to get from the publication of the book."

Jackson completed her novel in about three months. The main character, Ramona, half Indian and half Scotswoman, grows up as the ward of Señora Moreno, who does not love her. After marrying Alessandro, a full-blooded Indian, she becomes an outcast and a fugitive. The book recounts the couple's struggles to obtain their own land. In March 1883, Juan Diego, a Cahuilla Indian, was murdered. The

justice of the peace and the coroner's jury ruled the shooting justifiable homicide. In a newspaper article titled "Justifiable Homicide in Southern California" Jackson wrote, "It was easy to see that killing of Indians is not a very dangerous thing to do in San Diego County." According to historian Valerie Sherer Mathes, Jackson used the incident to create the fate of Alessandro, Ramona's husband, in the novel.

Although Jackson's novel was an instant success, it failed to arouse public concern for the treatment of local Native Americans. Jackson next planned to write a children's story about Indian issues, but she died before it was completed. In a letter sent to President Grover Cleveland, Jackson wrote, "From my death bed I send you message of heartfelt thanks for what you have already done for the Indians. I ask you to read my *Century of Dishonor*. I am dying happier for the belief I have that it is your hand that is destined to strike the first steady blow toward lifting this burden of infamy from our country and righting the wrongs of the Indian race." She concluded, "My *Century of Honor* and *Ramona* are the only things I have done of which I am glad....They will live, and...bear fruit." Jackson died on August 12, 1885.

In the ten months before Jackson's death, *Ramona* sold fifteen thousand copies, and it has gone through scores of reprints. It was first made into a film, starring Mary Pickford, in 1910 and has been adapted for other media, including stage and television productions. In 1886, a historic town in San Diego County was founded and named Ramona after the book. Since 1923, the *Ramona* pageant has been staged annually in Hemet, California. The script, adapted from Jackson's novel, features a cast of more than three hundred people and is the largest and longest-running outdoor play in the United States.

Historian Valerie Sherer Mathes concluded, "*Ramona* may not have been another *Uncle Tom's Cabin*, but it served, along with Jackson's writings on the Mission Indians of California, as a catalyst for other reformers....Her enduring writings provided a legacy to other reformers who cherished her work enough to carry on her struggle and at least tried to improve the lives of America's first inhabitants." As a result of Jackson's efforts and those the people who followed her lead, California passed the Act for the Relief of the Mission Indians in 1891, a bill that eventually set aside twenty-six reservations for 3,200 Mission Indians.

LYDIA KNAPP HORTON (1843-1926)

San Diego Public Library Supporter

Lydia Knapp Horton, wife and widow of city founder Alonzo E. Horton, was organizer and first president of the Wednesday Club, established in 1885. The club's purpose was to study "artistic and literary culture." After the club adopted obtaining a library building as its special project, Horton initiated the fundraising and led the campaign. She began correspondence with Andrew Carnegie in 1897 and by July 1899 had convinced Carnegie to pledge $50,000 toward the construction of a library, an amount he later increased to $60,000.

Horton was born Lydia Maria Smith on August 7, 1843, in West Newbury, Massachusetts. In 1861, she became engaged to Frank Fenelon Knapp, who served in the Civil War. After her fiancé died of yellow fever, Lydia became engaged to his brother, William Knapp, who was fifteen years her senior. They were married in 1866. Two months after they their marriage, William, who was in the navy, left on a lengthy voyage at sea.

After his return, her husband received an honorable discharge, and in 1869, the couple moved to San Diego. The Knapps became well known in the community, and Lydia participated in establishing a Unitarian Sunday school. Alonzo Horton and his wife, Sarah, were members of the Unitarian church, and the couple became friends. In 1873, the Knapps left San Diego and moved to San Francisco, where William Knapp later suffered a stroke and died in 1885. After his death, Lydia and her two sons, aged seven and ten, returned to San Diego.

After her arrival, Lydia became reacquainted with her former friends, Mr. and Mrs. Alonzo Horton. On May 17, 1889, while visiting in Washington, D.C., Sarah Horton was thrown from a carriage and killed. Horton was again a widower, and in the following year, he married Lydia Knapp. The *San Diego Union* reported their marriage: "The founder of San Diego, A.E. Horton, whom every man, woman and child knows as 'Father Horton,' took unto himself yesterday for the handsome mansion on the heights, a bride who will adorn it by her natural graces and high cultivation....He is thirty years senior of the bride, but is young in heart and certain he will live to see San Diego the metropolis of the coast."

Lydia Horton presided over the Horton mansion until 1892, when it was sold, and the couple moved to a smaller house on State Street that became known as Horton Hill. After her marriage, Lydia became active in cultural

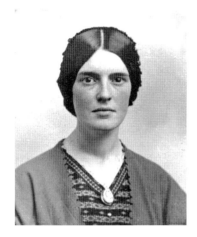

Lydia Knapp Horton (1843–1926), San Diego public library supporter. *Courtesy of the San Diego History Center.*

and art circles and developed an interest in improving the status of women. In late-nineteenth-century America, middle-class women established "Women's Voluntary Associations" to provide an opportunity for them to get together for self- and civic improvement. Horton had seen the growth of these associations in the East and was interested to see them established in San Diego. She believed that the role of women's clubs was to contribute to libraries, children's homes and other community needs. In 1895, a group of prominent San Diego women organized the Wednesday Club and elected Lydia Horton as the first president.

The following year, Horton conducted research and wrote a paper titled "Public Libraries" that she read to the Wednesday Club. Although a San Diego library had opened in rooms donated by the Consolidated Bank in 1882, it later moved to the St. James Hotel, and the city had long hoped for a permanent building. Following discussion, a vote was taken, and members agreed that the club should start a library fund. As a result of her work on behalf of the library, Horton was elected to the board of trustees of the San Diego Public Library in 1897.

After Horton learned that Andrew Carnegie was making grants to cities for library buildings, as secretary of the library board of trustees, she wrote to him and explained San Diego's pressing need for a library building. "The library needs of this place are very apparent," she wrote. "We have a good library of about 14,000 books, which we have in rented rooms, for which we pay $85 a month. Every few years we are obliged to move, owing to a demand for more room, or other causes. Our last moving expenses were about $800.

Carnegie replied to Horton's request, "Madam: If the city were to pledge itself to maintain a free public library from the taxes, say to the extent of the amount you name, of between five and six thousand dollars a year, and provide a site, I shall be glad to give you $50,000 to erect a suitable library building." Carnegie later added $10,000 to bring the total for construction of the San Diego Public Library building to $60,000.

When Carnegie's generous gift became known, J.W. Somers, a library trustee, wrote, "To Mrs. Lydia M. Horton, our efficient and honored secretary, we are indebted for securing this great benefaction. The building will in a measure be a memorial to her untiring energy and unselfish devotion to the interest of the public library. We owe her a debt of gratitude that we can never adequately repay." When the building's cornerstone was laid on March 19, 1901, Lydia Horton read a paper that told the library's history. She served as a member of the library board of trustees for seven years, and as a result of her recommendation, a Children's Room was created.

In the early twentieth century, Alonzo lost most of his properties through tax sales and foreclosures, and Lydia Horton had to go to work. She obtained full-time employment as a librarian at the State Normal School. In 1909, at the age of ninety-five, Alonzo Horton died. Lydia Horton's sons, William and Philip Knapp, came from San Francisco to comfort their mother. More than eight thousand people passed before his casket to pay tribute, and the streets were lined with throngs of people who viewed the cortege bearing his body to its final resting place. Although his funeral was the largest ever held in San Diego up to that time, other than the couple's home on State Street, Alonzo Horton left no estate.

After her husband's death, Lydia Horton pointed out that she had been employed as a librarian for six years and asked for a salary increase. According to historian Elizabeth MacPhail, there is no record of the response to her request, and in 1910, she submitted her resignation. Horton sold the State Street home for financial need, and her son Philip Knapp began sending her $100 a month, a contribution he continued for the rest of her life. She was then sixty-seven years old and free to actively participate in her beloved Wednesday Club. Women's right to vote had long been one of Horton's major interests, and she worked tirelessly for passage of the law granting women's suffrage in California in 1911.

Horton served on the Women's Board of the 1915 Panama-California Exposition planned for Balboa Park and was also invited to serve as honorary vice-president of the Panama Pacific Exposition in San Francisco. When the United States entered World War I, Lydia Horton was named vice-regent of the San Diego Chapter of the U.S. Service League, a civilian organization that aided servicemen, and she served as the organization's librarian for two years. In 1917, Horton moved into a small bungalow around the corner from the Wednesday Club and seven years later suffered a severe stroke. She died on October 17, 1926.

Historian Elizabeth MacPhail observed, "There have been many San Diego women who deserve to be remembered for their outstanding accomplishment and service to their community. None is more entitled to this recognition than Lydia Knapp Horton, the wife and widow of 'Father' Alonzo E. Horton."

Flora Kimball (1829–1898)

Feminist Writer and Community Activist

Flora Kimball was a community activist, lay horticulturist and writer who championed woman's suffrage and supported increased independence for women. She wrote with passion and persistence about the pressing concerns of rural women, their changing role within the family, work outside the home and the right to vote. At the time of her death, it was said that she was the most well-known woman in the state, and her eulogy was written by Susan B. Anthony.

Born in New Hampshire, Flora was one of ten children. She began her teaching career at the age of fifteen and eventually became a high school principal. According to her biographer Matthew Nye, Flora's experience as an independent woman who worked outside the home influenced her later writings. In 1855, Warren C. Kimball recruited Flora to teach in a school located in Contoocook, a neighboring town. Two years after her arrival, she and Warren were married.

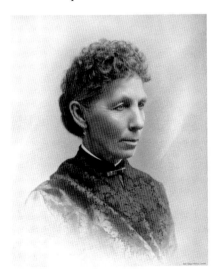

In 1861, Warren and his younger brother, Frank, who had married Flora's younger sister, Sarah, moved to San Francisco while their wives remained at home. The brothers set up shop as contractors and were successful in constructing homes and commercial buildings. The following year, their wives joined them. Flora Kimball became a correspondent for the publication *Rising Tide* and wrote

Flora Kimball (1829–1898), feminist writer and community activist. *Courtesy of the San Diego History Center.*

about topics that reflected her interests: plants and horticulture, education and the role of women in society.

In 1868, Frank Kimball decided to leave the Bay Area for a drier climate. After he and Sarah moved to the San Diego area, Warren and Flora soon followed. The brothers purchased and developed a former Mexican land grant, Rancho de la Nación, and named it National City. Warren and Flora built a stately home called Olivewood with extensive gardens that became a regional showpiece. An 1889 article published in the *National City Record* described the gardens as "a twenty-acre tract, the east half set in olives alone, and the west half in olives, various other fruits, lawns, flowers, and hedges. In all there are two thousand trees."

In 1867, the National Grange of the Order of Patrons of Husbandry was established. The Grange included a large number of agricultural organizations that sought economic and social change and was the first society to admit women to full and equal membership. Frank Kimball served as the first master of National City's local grange, and in 1879, Flora was elected master, the first woman in the country to hold the position. Flora Kimball was a prolific writer of both fiction and nonfiction works. As early as 1872, under the nom de plume F.M. Lebelle, she wrote the first novel published in San Diego County, titled *The Fairfields*. When the *California Patron*, a publication of Grange newspapers, included a feature for women called the "Matrons' Department," Kimball contributed articles and later became editor of the paper's women's section.

Kimball's articles combined a passion for women's social and political rights with a focus on women's relationships. "Much drudgery is borne by women for no other reason than because she is a woman," she wrote. "As a woman, I defend the right of women to 'life, liberty and the pursuit of happiness,' equally as men." In addition to the right to vote, Kimball championed other issues, including an eight-hour workday, equal pay for working women, divorce reform and self-support. "There is no sadder sight than that of young women who have been trained to luxurious indolence, bereft of means, with no trade or practical education, adrift on the world," she asserted. Her strongly held belief that young women should prepare for an independent life outside the home was revolutionary at the time.

In 1880, the National City Council authorized the civic-minded Kimball, a lay horticulturist, to obtain trees and supervise their planting throughout the city. She supervised the planting of numerous eucalyptus trees in various sections of the city, and in 1892, an additional five hundred trees were purchased. Eventually, nearly eight thousand trees were planted along the

city's curb lines, and they became a National City landmark. "No nature is so depraved that it does not respond to the refining influences of trees, their flowers, and fruits, and none so perfect that it may not be made pure and better by their presence," Kimball wrote.

The year 1889 was especially important for Kimball. She became the horticulture editor of a column, "Home and Family," in the *Great Southwest*, a monthly publication devoted to agricultural and industrial topics. Together with other socially prominent women, she participated in organizing a women's annex to the chamber of commerce, the first group of its kind in the nation. In the same year, Kimball was elected to the school board of the National City School District, the first woman in the state to receive that honor. As a result of her contributions to National City, Kimball was selected to represent Southern California on the board of managers for the upcoming 1893 World's Fair in Chicago. An article published in a local paper, the *Pacific Rural Press*, stated, "We can think of no one more competent and every way desirable for that honorable office than the lady mentioned. She would certainly do credit to our state."

In June 1895, Susan B. Anthony and Anna Shaw, renowned advocates for women's suffrage, were invited to speak in San Diego at the First Methodist Church. Kimball served as the meeting's chairman and, on the following day, hosted a large reception in their honor at Olivewood. The *San Diego Union* reported, "The guests of honor…Miss Susan B. Anthony and Rev. Anna Shaw and about 100 persons sat down to a most beautiful repast that had been spread upon tables on the lawn.…Miss Estelle Thompson read an original poem entitled 'Olivewood.' Miss Anthony called for 'Our Host, the Planter of Olivewood,' and Mrs. Kimball responded in a speech which elicited much applause." On October 21, 1897, the *National City Record* identified Flora Kimball as president of the Woman's Suffrage Club, a section of the San Diego Woman's Club that had been founded in 1892.

Flora Kimball died on July 2, 1898. Her obituary published in the local *Pacific Rural Press* stated:

> *How many of the older readers of the* Rural Home Circle *will grieve to hear of the death of Mrs. Flora M. Kimball of National City. The following fitting words to her memory are penned by G.P. Hall for the* San Diego Union: *"The death of Mrs. Flora Kimball, so universally regretted, removes a true friend and untiring helper of the horticulturist, one whose love for nature was ever manifest by untiring tests of her resources and prodigality. The monuments of praise she leaves behind are not only*

the trees with which she adorned her home and streets of the town, whose interests she labored to promote. Trees, plants, and flowers all stretch their arms toward heaven to silently tell of her disinterested benevolence, and in the wave of every breeze will send their incense from the world she helped to make brighter and happier."

Flora Kimball was a remarkable woman. Her writing and activism influenced progressive politics on a wide range of subjects: particularly women's rights, self-sufficiency and the vital connection between man and nature. The California Historical Society noted that Kimball wore her passions on her sleeve and sought to enhance the fabric of life in nineteenth-century California, particularly for women of her era and for future generations.

CHARLOTTE BAKER (1855–1937)

San Diego's First Female Physician

Charlotte Baker was San Diego's first female physician and the only female president of the San Diego Medical Society until 1887. She worked to eliminate prostitution, led the building of the San Diego Center for Children and co-founded the San Diego YWCA. A high point of her life was serving as a leader of San Diego's suffrage movement, which resulted in the women of California wining the right to vote in 1911. Baker also delivered about one thousand babies during her career and was proud that she never lost a mother in childbirth.

Baker was born Charlotte Le Breton Johnson in Newburyport, Massachusetts, one of five daughters of Nicholas Johnson and Caroline Pettingill. After completing high school in 1873, she graduated from Vassar College and attended the University of Michigan, where she studied medicine. At the time, the University of Michigan was the only coeducational medical school in existence in the United States, and Baker graduated with her medical degree in 1881. While there, she met Fredrick "Fred" Baker, a fellow medical student, and they married in 1882. The couple had two children, a son and as daughter, and practiced medicine for a year in Akron, Ohio, before relocating to Socorro, New Mexico. Believing that their children would have better educational opportunities if they moved to a more urban environment, the couple decided to move to San Diego in 1888.

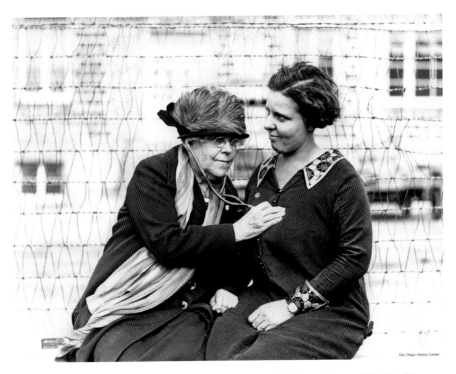

Charlotte Baker (1855–1937), San Diego's first woman physician. *Courtesy of the San Diego History Center.*

When the Bakers arrived, San Diego was experiencing a boom, and the population had reached forty thousand. The Bakers immediately went about the task of establishing themselves in their new community. Two days after their arrival, they joined the San Diego Medical Society. The goal of the society was to advance "medical science and the improvement of the fraternal and social relations of its members." Charlotte Baker became active in the society and served as vice-president in 1889 and then president in 1896.

Baker continued to be involved in the society and also became politically active. Many of her community activities illustrated her particular concern for women and children. She lobbied in Sacramento for an eight-hour day for nurses and advocated for welfare legislation that would protect female workers and provide assistance to women with young children. She also worked to promote pasteurization laws that would protect children and others from disease. Baker served as medical examiner for girls admitted to the State Normal School and regularly spoke at the campus on issues involving health and hygiene.

The Bakers were the first husband-and-wife physician team in town, working at St. Joseph's Hospital, where Dr. Charlotte practiced obstetrics and gynecology. She even delivered her future daughter-in-law Anne. According to Baker's biographer, Alma Kathryn Robens, Anne is quoted as saying, "She gave me my first spanking—not often a mother-in-law does that." When Anne gave birth, Baker also delivered her son, Baker's own grandson. An article published in a local medical publication reported that Dr. Charlotte Baker "boasted that she was first a physician and secondly a female," and she was regarded by her male colleagues as an equal who "could hold her own."

As the years passed, Baker transitioned from primarily working as a physician to being a civic-minded woman who actively participated in improving the lives of women and children. She contributed her services to the Presbyterian Chinese Mission, where she taught reading, writing and Bible studies to children, and organized the Girls Rescue Home, which served neglected, abandoned and "wayward" girls. The organization later changed its focus to the care of children and became the San Diego Center for Children. Even though she made contributions to many charitable organizations, it was to the YWCA that she devoted most of her time. In 1907, together with other prominent women, she founded the San Diego chapter of the Young Women's Christian Association.

Throughout the nineteenth century, granting women the right to vote was a significant political issue. The chance for California's women came in 1911, when the state legislature placed an amendment on the ballot that would enfranchise them. San Diego's suffrage campaign began at the YWCA, and Baker's travels across California representing the association led her to meet many women who campaigned for passage of the women's vote amendment. She helped to mobilize women for the cause and served as president of the San Diego Equal Suffrage Association.

According to historian Marilyn Kneeland, the group's initial strategy was to invade every house. "Every man whose name appears on the register will be interviewed by a committee of women. Of course, if we find out a man who isn't with us, we intend to keep right on him until he is convinced." The San Diego campaign began in July 1911 with a huge parade. In her diary, Baker described the association's float. It used yellow ribbons and 'billowing yellow sails; that bore the legend 'The Modern Boston Tea Party' and the slogan 'Taxation Without Representation Is as Much of an Injustice Now as in 1776.'" San Diego suffragists also used education to promote their message. In early September, Baker and other supporters

toured San Diego's backcountry in a banner-decorated automobile. The women visited Oceanside, where they spoke from benches; stopped in Escondido; and visited Fallbrook and Ramona distributing literature and arguing for suffrage.

In October 2011, local author Anne Hoiberg published an editorial in the *Union-Tribune* marking the centennial of the campaign for the passage of women's suffrage. She wrote:

> *With the arrival of election day on October 10, San Diego suffragists worried that the amendment was headed for defeat. In her diary, Dr. Baker recorded her concerns: "Between five and six bad reports from San Francisco made us feel blue. But cannot give up hope." Local results favored women's suffrage: 3,331 San Diego men voted "yes" and 2,464 voted "no." The final statewide count showed 125,037 for the amendment and 121,450 against. California women were granted the right to vote!*

After suffrage was achieved in California, Baker focused her efforts on eliminating San Diego's red-light district, also known as the Stingaree. She and Ellen B. Allen believed that women were more sinned against than sinners and formed the Purity League, later called the Vice-Suppression League. The organization's goal was to rid the city of prostitution by closing the red-light district. In November 1912, police raided the district and rounded up the women who left the city.

Baker's continuing interest in the suffrage issue brought her into politics. She continued to make the passage of a national amendment to grant suffrage an agenda item in all her meetings at the YWCA and the Women's Civic Center, a group that focused on rescue work to "lend a helping hand to those unfortunates who desire to lead a clean life." According to biographer Alma Kathryn Robens, on the occasion of her fiftieth wedding anniversary, Baker remarked that her greatest accomplishment was campaigning for suffrage. She stated that "at heart I am a politician. I am sorry to see the meaning of that term has been corrupted until it is in disrepute. It is a fine thing to take an active interest in politics. It has always been a hobby of mine."

Charlotte Baker died on October 31, 1937, after a long illness. One obituary stated that she stood "unflinching by a cause she espoused. She neither shrank from opposition nor refused to assume responsibilities. She cowered before no adversary." Baker led a remarkable life. She helped establish the fledgling medical society and many other community organizations while meeting the commitments of her own medical profession.

KATE SESSIONS (1857–1940)

Mother of Balboa Park

Kate Sessions was one of California's first environmentalists long before the term became popular. Her work in plant introduction won international recognition, and she was the first woman to be awarded the prestigious Frank N. Meyer medal of the American Genetic Association. In 1892, Sessions leased land for a nursery in "City Park" where she began planting one hundred trees a year. She also planted at least three hundred more throughout the San Diego area. It is for the creation of Balboa Park that she is most remembered. A bronze statue of Sessions guarding the park's entrance is the only full sculpture in the city dedicated to a real-life woman, the "Mother of Balboa Park."

Kate Sessions was born in San Francisco, the first child of Josiah and Harriet Parker Sessions. In 1868, the Sessions family moved across the bay to Oakland, which was still a small village with lots of open space. After living in a crowded city, the move enabled her to roam about the countryside and observe the trees, plants and wild flowers in her new home. After graduating from high school in Oakland, Sessions attended the University of California–Berkeley, where she studied science. Her graduation essay, written in 1881, was titled "The Natural Sciences as a Field for Women's Labor."

In 1883, Sessions relocated to San Diego and briefly taught before moving on to study the cultivation of plants. Two years later, she became a partner in the San Diego Nursery and soon developed a national reputation. On September 8, 1890, an article that appeared in the *Boston Globe* stated, "A young woman in San Diego in the southern part of California is doing a paying business in both wholesale and retail plant trade. She was a school teacher, did not like teaching, and had a wholesome love of botany. She started a florist's shop which has developed later into a nursery." Sessions eventually purchased nurseries in Coronado, Mission Hills and Pacific Beach.

From 1891 to 1893, Sessions wrote a series of articles titled "Notes on Planting" that were published in the *San Diego Union-Tribune*. Her articles included detailed instructions as to when and how to plant a particular flower, tree or shrub and made her name familiar to home owners struggling with San Diego soil and trying to beautify their gardens. As a result of her reputation for horticultural expertise, particularly landscaping and plant introduction, she frequently contributed articles to *California Garden*, a

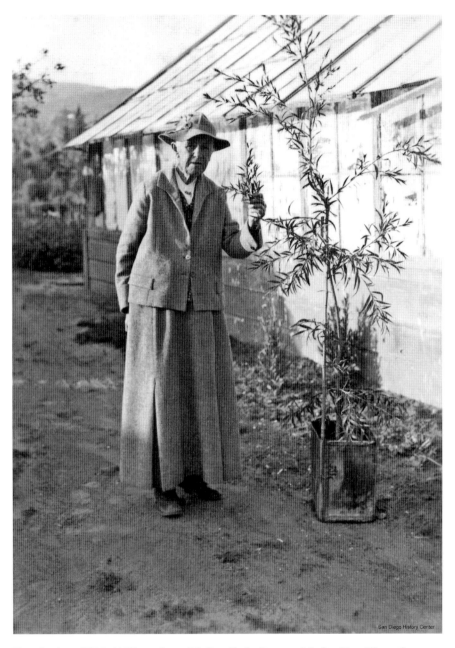

Kate Sessions (1857–1940), mother of Balboa Park. *Courtesy of the San Diego History Center.*

publication of the San Diego Floral Association, the oldest garden club in Southern California.

On February 17, 1892, San Diego passed City Ordinance No. 153 granting "K.O. Sessions the right to use and occupy certain lands" in what was then called City Park "for the purpose of establishing an experimental nursery and garden, and for the development and cultivation of said City Park for a period of not exceeding ten years." The section of the park leased was the northwest corner of Sixth and Upas Streets, covering some thirty acres. However, she actually cultivated and used only about ten acres. Other provisions were that "the city would not bear any expense for fencing, or piping water to the land, and the grounds were to be at all times open to the public (on foot)." The ordinance further provided that she was responsible for "planting 100 trees a year in the park and also furnishing annually to the city 300 ornamental trees in crocks or boxes to be used by the city in park, street, plaza or school ground planting." Many of the older trees that still exist in Balboa Park were originally planted by Sessions.

Sessions also imported and popularized the jacaranda, a flowering tree with lavender tubular blooms, and the Tijuana tipu, a tree with wide canopies commonly used to provide shade. One of these trees, planted by Sessions at the site of her former Pacific Beach nursery, is a California Historical Landmark. A plaque attached to a boulder at the corner of Garnet and Pico Streets states: "Kate Olivia Sessions Nursery Site (1857–1940): This plaque commemorates the life and influence of a woman who envisioned San Diego beautiful. On this site she operated a nursery and gained world renown as a horticulturalist. She was the first woman to receive the international Meyer medal in genetics."

In 1897, San Diego decided to beautify Horton Plaza in the heart of downtown. Sessions was consulted and recommended introducing the *Cocos plumose* palm because it would grow tall and not obscure the view. Almost without exception, all of the Cocos plumose palms today, including those in Balboa Park, were grown from seedlings in her nursery. She personally planted stripling *Cocos plumosas* in the plaza, selecting only the finest specimens, and over the years watched them grow to their full height and beauty.

In 1899, Sessions was invited to take over management of the Hotel del Coronado's botanical gardens. In addition to supervising the botanical garden and supplying the hotel with cut flowers, she was responsible for selling the excess flowers. A small structure built in the hotel courtyard was soon covered with red bougainvillea and became her flower stand. Although

she remained in charge of the hotel garden for only a short time, the bougainvillea-covered house in the center of the hotel courtyard remained a colorful attraction for many years.

On March 7, 1904, as a result of Sessions's suggestion, San Diego celebrated Arbor Day for the first time. A school holiday was declared and 2,500 schoolchildren and 4,000 adults turned out to plant trees in City Park. Sessions supervised the event and recommended the variety of trees—mostly firs, pines and Monterey cypress—to be planted. As a result, the city received a message of congratulations from President Theodore Roosevelt and the governor of California at the time, George Pardee. For many years, San Diego schoolchildren continued to celebrate Arbor Day with tree plantings at their individual schools.

In 1915, Sessions was appointed supervisor of agriculture for San Diego City Schools, responsible for landscaping and teaching horticulture and botany to the children. Each school was required to use a nearby lot on which the children grew vegetables and flowers as a lesson in agriculture. She illustrated her talks with twigs, blossoms and branches and asked the children to bring samples of plants from their home gardens to class. Sessions would identify the country of origin for each specimen and explain how best to care for it to ensure healthy growth. According to Sessions's biographer Elizabeth C. MacPhail, "She made her talks so interesting and her personality was so striking that the children never forgot what they learned from her."

In July 1909, the chamber of commerce suggested that San Diego hold a World's Fair in 1915 to celebrate the opening of the Panama Canal. The following year, after a contest to select a name for City Park, the Board of Park Commissioners formally named it Balboa Park. When the Panama-California Exposition opened, over 1,200 varieties of plants had been brought in to add to the beauty of the trees and lawns—all growing out of what previously had been only a barren wasteland. Kate Sessions actively participated in the landscaping of the park and exposition grounds and became ever after known as the "Mother of Balboa Park."

Sessions, who never married, died on March 24, 1940, at the age of eighty-two. She has been described by her biographer as "a woman who was a walking encyclopedia on botany and horticulture, and who was able to instill a love for plants in all those who came under her influence."

1900–1950

One of the most beloved women in San Diego was Ellen Browning Scripps, who significantly contributed to the city's development. In 1900, after her brother George H. Scripps died and left her stock in the *Cleveland Press*, she moved to San Diego and began a new life as a philanthropist. A shrewd businesswoman, Scripps donated millions to research facilities, colleges, hospitals and numerous other San Diego institutions.

In 1915, San Diego hosted the Panama-California Exposition to celebrate the opening of the Panama Canal in Balboa Park. A concurrent project completed at the time was the restoration of the Casa de Estudillo by Hazel Wood Waterman, a well-known designer of local homes. The historic adobe house located in Old Town is one of the oldest surviving examples of Spanish architecture in Southern California.

The Panama-California Exposition led to establishment of the San Diego Zoo. After the exposition ended, Dr. Harry Wegeforth and four other men acquired the remaining animals and added a few more from a defunct carnival. The city council donated ten acres of parkland, and a permanent tract of land in Balboa Park was set aside in 1921. Four years later, Dr. Wegeforth hired Belle Benchley as the zoo's bookkeeper. In 1927, she was promoted to the position of executive secretary, and her title soon changed to director of the San Diego Zoo. Benchley served as zoo director from 1925 to 1953 and became known as the "Zoo Lady."

Between 1883 and 1929, philanthropist Andrew Carnegie funded construction of more than one thousand libraries in the United States,

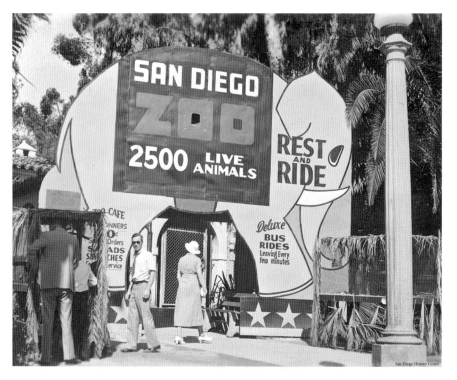

San Diego Zoo. *Courtesy of the San Diego History Center.*

and San Diego became home to California's first Carnegie library. Althea Warren, San Diego Public Library's first professionally trained librarian, reorganized and modernized the Carnegie library. She served as head librarian from 1916 to 1926, and under her tenure, the library earned the 1921 American Library Association distinction of having the largest circulation in the United States for cities of comparable size.

In the early twentieth century, aviation captured the nation's interest, and the achievements of young aviator, Ruth Alexander, were closely followed. In 1930, she established a world record for light planes rising 26,600 feet and successfully completed a three-country flight along the Pacific coast. Next on her agenda was a cross-country flight to the East Coast. On September 18, 1930, only minutes after taking off from Lindbergh Field, she crashed on a hillside in Point Loma. Ruth Alexander is remembered as a trailblazing woman of the airways.

While World War II fought injustice in Europe, there also was a struggle for human rights on the homefront. San Diego became a major employer in the

defense industry, but Mexicans were not hired to work in war-related fields. Luisa Moreno, a renowned civil rights activist and labor leader, condemned discrimination. She fought for the rights of female cannery workers and succeeded in bringing thousands into the ranks of organized labor.

Established in 1949, the University of San Diego admitted its first students in 1952 as the San Diego College for Women. Mother Rosalie Hill, who designed the college, believed strongly in the importance of beauty and decided that the architecture of the college should be an adaptation of Spanish Renaissance style. She also planned the chapel, which has been described as "a great monument to those who conceived it and to those who enabled the dream to become a reality."

Madge Bradley was the first female judge in San Diego County. During her career, she was the first woman on the board of directors of the San Diego County Bar Association, the first San Diego County woman to be appointed to a state bar committee and San Diego's first female judge. The Madge Bradley building of the San Diego County Superior Court is named in her honor.

The eight women profiled in this era were true pioneers. Although most women had broken away from the burdens of Victorian domesticity, few kept their jobs after marriage. Attempts to combine family and careers were mostly confined to those who opted for work and childless marriages, and female professionals were almost entirely concentrated in four areas: teaching, nursing, social work and libraries. It was not until the feminist movement of the 1970s that conventional assumptions about the role of women began to change.

ELLEN BROWNING SCRIPPS (1836–1932)

Journalist and Philanthropist

Since *Time* magazine's beginning in 1923, few women have graced the periodical's cover. In 1926, Ellen Browning Scripps became a member of that exclusive club. Identifying her as the "most beloved woman in Southern California," *Time* recognized Scripps for her philanthropy to numerous health, educational and cultural institutions. After founding the Scripps Institution of Oceanography, she helped to establish or fund Scripps College, Scripps Memorial Hospital, the San Diego Natural History Museum, the

Ellen Browning Scripps (1836–1932), journalist and philanthropist. *Courtesy of the San Diego History Center.*

Bishop's School, the La Jolla Women's Club, La Jolla Athenaeum Music and Arts Library and the La Jolla Recreational Center. To protect the rare Torrey pine tree for future generations, she purchased and donated to the state a tract of land with the provision that the parcel, now called Torrey

Pines State Natural Reserve, remain undeveloped forever. Even Balboa Park benefited from her generosity. The world's largest aviary, located in the San Diego Zoo, was a gift from Scripps.

Ellen Browning Scripps was born in London, England. Her father, James, was a book binder, and her mother was the daughter of a customs clerk. She was only four and a half when her mother died, leaving Scripps and her five siblings behind. In 1844, when Scripps was seven, her father relocated his family to a farm in Rushville, Illinois. After the move, her father remarried and had five more children.

Scripps taught school for two years and then enrolled at Knox College. After graduation, she returned to teaching in public and private schools. In 1873, her elder brother James founded the *Detroit Evening News*, and she worked on the paper as a proofreader, copy editor and columnist. She wrote a front-page feature called "Matters and Things" that included her opinions on women's suffrage and prohibition. Scripps successfully persuaded James to take their younger brother Edward, also known as E.W., into the business, and he later established his own paper in Cleveland, the *Penny Press*. Her brothers continued buying newspapers, including the *Cleveland Press*, *St. Louis Chronicle* and *Cincinnati Post*, until they had created a twenty-four-newspaper chain consisting of major papers across the country. Investments in her brothers' newspapers gave Scripps financial independence and made her a wealthy woman.

In 1881, Scripps toured Europe and North Africa with E.W. and shared her travel experiences with readers of the *Detroit Evening News* in the form of letters, which were published in place of her usual column. According to her biographers Patricia Daly-Lipe and Barbara Dawson, Scripps's letters from abroad made her the first female foreign correspondent (with the exception of Margaret Fuller, the first foreign correspondent of either sex, who wrote for the *New York Tribune*). Her column eventually became one of the world's largest newspaper features, distributed daily to about one thousand newspapers in the country.

In 1890, Ellen Browning Scripps and her brother Fred set off for California and traveled south to San Diego to visit their cousins. They toured the city, including Old Town, Point Loma, the City Park (later named Balboa Park) and La Jolla, a small seaside community. Both were captivated by San Diego's warm, dry climate as well as its opportunities for investment. In 1896, Scripps, then age sixty, bought two large lots in La Jolla on Prospect Street across from Draper Street on one side and sloping down to the ocean on the other. The following year, she built her

first house and named it "South Moulton Villa" after the street on which her family had lived in London.

When her bachelor brother George died in 1900, he left the bulk of his estate, including stock in the *Cleveland Press*, to Scripps. She decided to use her inheritance in a way to honor him, a yachtsman with scientific interests. In 1903, she and E.W. assisted a Berkeley biologist, William Ritter, in establishing the Marine Biology Association of San Diego. She provided an endowment of $50,000 per year, and members of her family contributed the entire operating budget. It was Ellen Browning Scripps's money that built the roads and the pier, the first laboratory building and the first library. In 1912, the station was acquired by the University of California and renamed the Scripps Institution of Oceanography.

When Scripps was a student at Knox College, women could not receive college degrees, and she wanted to increase educational opportunities for women. In 1909, the bishop of the Episcopal Diocese of Los Angeles sought her help to fund a college preparatory school for girls. She had been an early supporter of women's suffrage and willingly donated land to establish the Bishop's School in La Jolla. She commissioned its first building, provided scholarships and remained one of its most important contributors. In 1926, the vision of a group of small residential colleges in Claremont, California, associated with the model of Oxford University, won her support. She helped to found the second member of the group, a college for women that was named Scripps College in her honor. She was insistent that women should prepare themselves for exercising the right to vote, and education in various forms, particularly for women, was a central focus of her philanthropic legacy.

Scripps donated generously to numerous projects that supported her love of nature, medicine and humanity. In 1911, she became a member of the Egypt Exploration Fund and provided support for its expeditions. Her efforts resulted in the San Diego Museum's Ancient Egyptian collection. She also helped finance the new headquarters of the San Diego Natural History Museum. Scripps commissioned works by local artists and architects, including Irving Gill, and provided money for the publication of scientific books, especially those that documented the natural history of San Diego. In 1924, while recovering from a broken hip in a poorly equipped facility in La Jolla, Scripps became determined to build the best hospital she could for the city she had come to love. Scripps Memorial Hospital initially was founded on a site on Prospect Street in La Jolla. She also founded Scripps Metabolic Clinic (now Scripps Clinic) in 1924.

Scripps, who never married, was admired and loved by family and friends alike. Her nephew Thomas O. Scripps wrote, "Aunt Ellen had the heart of a nurse, the courage of an astronaut and a capacity to give both generously and wisely....I loved her very, very much as I am sure everyone does." During her last thirty years in La Jolla, Scripps joined various local clubs, played cards, took part in plays and toured California in her chauffeur-driven Rolls-Royce. When she was well over ninety, Scripps commented, "Of course I know I may die any time. I do not fear death, but I should like to live a little longer....Oh, life is just beginning to be so very interesting."

On August 3, 1932, only three months before her ninety-sixth birthday, Ellen Browning Scripps died in her La Jolla home. In accordance with her instructions, her body was cremated, and her ashes were scattered at sea from the deck of the R/V *Scripps*, a research vessel of the Scripps Institution of Oceanography. The Philanthropy Hall of Fame described her as a woman who "saw herself primarily as an investor in human capital, rather than an almsgiver." After her death, her contributions to American journalism were recognized by leading newspapers, including the *New York Times*, which praised her as "one of the pioneers in modern American journalism."

HAZEL WOOD WATERMAN (1865–1946)

Renowned Architect

Hazel Wood Waterman was a pioneering architect who designed numerous homes and gardens in San Diego. Her significant contributions to the city were not limited to domestic or residential structures. They included the historically accurate restoration of the Estudillo family home in Old Town, one of the oldest surviving examples of Spanish architecture in California. Waterman was San Diego's first female architect and also held the distinction as the second female architect in the state.

Waterman was born in 1865 in the small town of Tuskegee, Alabama, where her father, Jesse Wood, served as president of the Tuskegee Female College. In 1868, the family moved to California and settled in the Central Valley. She attended the University of California–Berkeley, where she met Waldo Sprague Waterman, son of Robert Waterman, seventeenth governor of California. They were married in 1889 and moved to Julian. Waldo had received training as a mining engineer and supervised his father's mining operations in the town. While in residence

Hazel Wood Waterman (1865–1946), renowned architect. *Courtesy of the San Diego History Center.*

at the mine, Hazel Waterman's major role centered on her home and her husband's activities.

In 1893, seeking more modern conveniences and a better school system for their children, the family moved to San Diego. Waterman's initial exposure to architecture took place in 1901, when she and her husband hired prominent architect Irving Gill to design their home, a stone cottage located on Hawthorn Street. After Waldo's untimely death from pneumonia at the age of forty-three, her life changed dramatically. Left only with life insurance and a few investments, Waterman needed additional income. She decided to pursue a career in architecture and enrolled in correspondence courses to study mechanical drawing and drafting. In 1904, she found employment with the architectural firm of Hebberd and Gill. Gill thought she had a natural talent for architecture and served as her mentor.

After working at the firm for three years, Waterman decided to open her own office. She received her first commission from San Diego socialite Alice Lee to construct a group of three homes on Seventh Avenue across from the west rim of a canyon in Balboa Park. The houses were designed in a U shape that included a common garden designed by renowned horticulturist Kate Sessions. The completed structures immediately led to other requests for her services. For the next several years, Waterman designed many Arts and Crafts–style homes and gardens in the San Diego area and developed an outstanding reputation as a versatile architect who designed not only a residence's exterior but also the interior.

In 1910, entrepreneur John D. Spreckels selected Waterman to restore the landmark Estudillo House, which had been constructed in 1827 and was one of the oldest structures in Old Town. The adobe house had become well known from its description as Ramona's marriage place in Helen Hunt Jackson's bestselling novel *Ramona*. Due to vandalism and the caretaker's selling off pieces of the house as *Ramona*-related relics, the structure was nearly in ruins. Although restoration of the dilapidated house was a complete

departure from her previous projects, Waterman accepted the challenge. Waterman wanted the building to be authentic in every detail and began researching how adobe structures were built during California's Mexican period. According to her biographer Sally Bullard Thornton, Waterman gathered information from original manuscripts, old photographs and interviews with the city's Mexican and Spanish residents.

Waterman wanted the tiles and adobe to be prepared in the original manner and handmade by Mexican laborers. The preparation consisted of a composition of coarse gravel, stable straw, soft black clay and broken shells or seaweed carefully kneaded with bare hands. Because the old walls had cracked in different sections, they had to be bonded with sufficient adobe and broken tile to achieve the desired uniform thickness. Materials intended for wharf piles and telephone poles provided by the Spreckels Company were cut to required dimensions and substituted for the roof timbers. A typically Hispanic original floor plan was followed with each room opening to a long veranda. Irregular tile floors, white walls and blue-stained woodwork were all similar to that which would have been found in the original house. The building had thick adobe walls with niches for a crucifix or religious statue, and every bedroom had a single barred window facing the street side.

Restoration of Casa de Estudillo met with rave reviews, and it became a popular tourist destination. Spreckels's streetcar line ran to Old Town, and he used the house to promote tours from his Hotel del Coronado. Marketed for decades as Ramona's Marriage Place and not the Casa de Estudillo, this historic home became more closely linked to a novel than its true history. The house eventually passed through several owners and was donated to the State of California in 1968. Over the years, it was further restored and was listed as a National Historic Landmark in 1970.

Waterman's role in the restoration of the Estudillo House led to other notable commissions. She had served on the board of the Wednesday Club, a prestigious women's civic club founded in 1885, and was selected to design and construct the club's new building, to be erected at Sixth Avenue and Ivy Lane. The work was completed quickly, and in the spring of 1911, the Wednesday Club members celebrated the opening of their new building. From 1912 to 1925, Waterman's career achievements included a sizeable residence in the exclusive Bankers' Hill area, an administration building for the Children's Home Association of San Diego, and a unique garden commissioned by Julius Wangenheim that received a certificate of honor from the San Diego chapter of the American Institute of Architects.

Waterman's architectural philosophy of total site development was summarized in a magazine article published in 1921 titled "The Figure of the House." In her discussion of home design, she stated that the ingredients for an ideal home required cooperation of the architect, home owner, builder and interior decorator. She believed that special attention should be given to the location of the view, position of the sun and condition of the soil. After consideration of these factors, the architect could work the house's floor plan to maximize the best elements. For Waterman, it also was important to design a home that was comfortable, functional and attractive and that reflected the homeowners' personalities. Only then could the completed structure meet all her criteria.

Waterman continued her architectural practice through 1929. In her later years, she concentrated her professional efforts on homes for her children, Helen and Waldo, and brother, Judge Walton J. Wood. According to her biographer, Sally Bullard Thornton:

> *Throughout her life, Hazel remained active with the same drive and pioneer spirit which gave her distinction as the second female architect in California. Hazel Wood Waterman, a truly talented and caring person, had dedicated herself to a philosophy of concern for the comfort and well-being of others. In all her activities, as well as in her family life, she also exemplified the determination required to achieve greatness in the second half of life's cycle. She would have been a remarkable woman in any age.*

Hazel Wood Waterman died on January 22, 1948, at the age of eighty-two.

BELLE BENCHLEY (1882–1972)

The Zoo Lady

The San Diego Zoo, founded in the waning days of the Panama-California Exposition, hired Belle Benchley as a bookkeeper in 1925. Two years later, she became its director. For most of her career, she was the only female zoo director in the world. In addition to administration, her responsibilities included building the collection of animals, pioneering new forms of exhibition and growing the membership. Under her direction, the zoo was one of the first to put animals into open-air, cage-less exhibits that re-created their natural habitats, and the San Diego Zoo grew into a major world zoo.

San Diego History Center

Belle Benchley (1882–1972), the zoo lady. *Courtesy of the San Diego History Center.*

Belle Jennings was born in Larned, Kansas, and came to San Diego with her family at the age of five. She attended a one-room grammar school, later went to Russ High School (now San Diego High) and graduated from San Diego Normal School (now San Diego State University). After graduation, Benchley taught for three years on the Pala Indian Reservation in the hills northeast of San Diego. In 1906, she married William L. Benchley and spent the next seventeen years in Fullerton, California, as a wife and mother. After

her marriage ended in divorce, she returned to San Diego with her teenage son and sought employment. In 1925, Dr. Harry Wegeforth, founder and director of the San Diego Zoo, hired her as a bookkeeper.

Benchley knew nothing about bookkeeping, but she had two qualifications that fit her for the job. She was never afraid to try something new, and she loved animals. Soon after being employed, she began roaming the zoo grounds and spending her lunch hour in front of one cage or another, observing the animals and asking questions of their keepers. Cage by cage, she learned the feeding procedures, habits and upkeep requirements of each animal. When she found problems, Benchley reported them to Dr. Wegeforth, and he would respond, "Well, do something about it." As a result, she took it upon herself to change the diet of a sick monkey or move a tiger into a larger cage. She wrote articles about the zoo for a local newspaper, solicited donations and visited local grocers to ask for free food for the animals. In 1927, Benchley was promoted to the position of executive secretary, which was then the top staff position.

Since the zoo's beginning, several directors had been hired. One of them was Frank "Bring 'Em Back Alive" Buck, who was famous for his exploits as a wild animal hunter. Although he constructed new exhibit cages and acquired new animals for the collection, Wegeforth and the independent-minded Buck did not get along. After only three months, he was fired. Buck was followed by three other unacceptable directors. In 1927, members of the Zoological Society recognized that Benchley was assuming more and more of the daily running of the zoo and appointed her as director. "Go ahead and run the place," she was told. "You're doing it anyway."

Some male Californians resented a woman serving as director. In her memoir, Benchley recounted a tragic event involving the zoo's bears. One day, when the zoo was full of visitors, a few of the grizzlies found an open gate and escaped. The tranquilizer gun had not yet been invented, and a police officer, fearing for the safety of the public, shot and killed one of the bears. Benchley wrote, "As always, much criticism was heaped upon the zoo management and the police officer who shot the bear. One priceless card came to me, which told me that it was all because I was a woman and incompetent; that if I had had a man in charge of the zoo, the bear would have been lassoed and dragged back into the grotto."

Benchley's devotion to animals was legendary. She circulated through the zoo at least once daily, keeping herself apprised of the status of each animal. Often she was able to detect an animal's illness even before its keepers or veterinarians. Abuse or neglect of the animals was not tolerated. When

an animal seemed to mistrust or fear a keeper, even if Benchley did not understand the reason for such feelings, the keeper was fired. The core of her approach was to place the animals' welfare at the head of the zoo's list of priorities. Zookeepers and visitors alike who teased or injured animals were told never to return.

Benchley wanted the animals to have the feeling of being in the wild. All animals were kept in family groups and provided with as much space as possible. They were given natural environments, and except for the snakes, were kept outside. Cage-less enclosures with large open-air grottos surrounded by moats replaced the steel cages of the past. Each animal was given a place where it could be by itself when it felt stressed or anxious. Benchley believed that animals should not be forced to have more contact with humans than they wanted, even if their public exhibit remained empty.

After redefining how the animals were to be exhibited and treated, Benchley proceeded to create a new support structure for them. She introduced the zoo's first animal hospital and developed a comprehensive nursery program. Infant mortality was significantly reduced, and the animals' average lifespans increased. Death-prone koalas thrived for years and seals for decades, and as a result of the reduction in stress brought about by larger enclosures, the zoo experienced the first captivity birth of numerous species. Today, every zoo in the country is, to some extent, an imitation of Benchley's model.

Under her leadership, the San Diego Zoo's annual attendance grew by four and a half times and its budget by seven times. Benchley collected memorable zoo tales that she shared in hundreds of radio and television appearances; by giving talks in clubs, schools and lecture halls; and through the zoo's publication, *Zoonooz*. She was the author of several books, including *My Life in a Man-Made Jungle*, *My Friends the Apes*, *My Animal Babies* and a children's book, *Shirley Visits the Zoo*. Benchley served on committees of the American Zoological Association and was its first female president. She also was a member of the International Union of Directors of Zoological Gardens.

Emily Hahn, author of *Eve and the Apes*, attended a meeting of the American Association of Zoological Parks and Aquariums in San Diego and described attendees' reaction when Benchley entered:

> *On the last night of the conference we had a farewell dinner and were happily talking when there was a stir and a sudden stop in conversation. Everybody looked at the door, and my dinner partner said, "There's Belle Benchley!" There she was, a frail elderly lady with glasses and walking*

stick. There was a general rush to greet her. Everybody wanted to talk to her, everybody seemed to love her—and these were humans, mind you. I like to imagine what her reception would have been like if we had been apes from the zoo.

When Benchley retired in 1953, the mayor of San Diego proclaimed "Belle Benchley Day," and a dinner held in her honor was attended by more than eight hundred people. She died in 1972 at the age of ninety and is buried in Greenwood Memorial Park in San Diego, where her gravestone features the carving of a smiling gorilla. Today, the world-famous San Diego Zoo runs extensive programs in the preservation of endangered species and continues to improve the natural habitat enclosures introduced by Benchley nearly a century ago. She is still recognized as one of the all-time great zoo directors and is known by generations of children as the "Zoo Lady."

ALTHEA WARREN (1886–1958)

City Librarian

Althea Warren was a prime mover in the modernization of California's libraries in the first half of the twentieth century. In 1914, she moved to San Diego, where she secured a position as the San Diego Library's first professionally trained librarian. Two years later, she was appointed city librarian, a position she held for the next decade. Under her tenure, the San Diego Public Library earned the 1921 American Library Association distinction of having the largest circulation in the United States for cities of comparable size. Warren served as California Library Association president in 1921 and American Library Association president in 1943–44, the first Californian to hold that office.

Warren was born in 1866 in Waukegan, Illinois. Her father, Lansing, was a well-known newspaperman who became financial editor of the *Chicago Daily News*, owner of the *Denver Times* and editor and manager of the *Milwaukee Sentinel*. Her mother, Emma, was well read and provided inspiration, and her grandfather Judge Henry Williams Blodgett of the U.S. District Court of Chicago is credited with selecting books for his granddaughter.

In the fall of 1904, Warren entered the University of Chicago and later described her introduction to university life. "I entered the University of Chicago with a scholarship so that I was expected to work in payment for

Althea Warren (1886–1958), city librarian. *Courtesy of the San Diego History Center.*

freshman tuition. I was assigned to the library. I practiced the clear, round hand in which catalog cards were then written. I never succeeded in doing any that were fit for use but I saw enough of the system of filing, of searching for the data needed in a bibliography, and of periodical indexing to be fascinated by the order and exactness." After graduating from college in 1908, Warren entered the library school at the University of Wisconsin.

In 1911, she obtained her first professional position as branch librarian with the Chicago Public Library. Warren was initially assigned to a grade school that she viewed as "the most insignificant of nearly fifty branches" located in "the worst slum section of the Northeast side." Her second appointment was to the library's Sears Roebuck branch, which was maintained for the store's employees. Warren recalled her early experience on the job. "I received notice at the end of my first month that I had been reported late sixteen times! My next purgatory was being told by the directress of women's welfare that my shirt waist with short sleeves was inappropriate for an office." Nevertheless, her first attendance at an American Library Association meeting was paid for by Sears.

In 1914, Warren's family left Waukegan and moved to California. Soon after her arrival, Warren learned of an opening for a librarian in the San Diego Public Library and applied for her third position. As a result of her recommendations, she was hired as the first professionally trained librarian to join the staff. Susan Smith, for many years a librarian at the California State Library, described Warren's first introduction to California library circles. She stated, "My acquaintance with Althea Warren goes back many years to the time when she first attended a meeting of the California Library Association in 1915. Some of the self-made, dedicated librarians were somewhat resentful of the professionally trained librarians from 'the East' who were taking over the old established libraries and instituting new methods of administration. Althea was no exception. She was treated with polite reserve but no cordiality."

Warren described the San Diego Public Library building located at Eighth and E Streets, funded by Andrew Carnegie and opened in 1902, "as constricted as a cemetery vault and with funds in inverse proportion to the demands of a growing city." By 1910, the population of San Diego had more than doubled in size, and the library lacked adequate room. Shelving covered every available wall surface, books were piled on floors and cataloging was ten years behind. Although overwhelmed by the conditions, Warren organized classes, gave lectures and made recommendations to remedy problems. In 1916, she was appointed head librarian.

Clara Breed, author of *Turning the Pages: San Diego Public Library History* identifies a number of changes Warren made after assuming her new position. Staff meetings were held between 8:30 and 9:00 several mornings every week to discuss reorganization of the library, train staff members and listen to their suggestions. Borrowers were reregistered and given their own library cards for the first time, instead of having them kept at the library. Saturday morning story hours for children were initiated, and a major rearrangement of the book collection combined the former Men's and Women's Reading Rooms into one Periodical Room on the first floor.

In an article titled "Increasing the Appropriation for the Public Library," Warren wrote that "the public library is nearly always the poorest of the city departments and accordingly, the tradition is to give it Cinderella's share." She viewed library salaries as humiliating and declared, "A library desk attendant should certainly rank higher than a dish washer or a cash girl." In 1925, her last year in San Diego, she was still striving to get a larger book fund, a new library building and better salaries. In the same year, Warren asked for a leave of absence to care for her ill mother, who was living in Los Angeles. Soon after coming to Los Angeles, Warren was offered the position of assistant city librarian for the Los Angeles Public Library. Her biographer Martha Boaz wrote, "She resigned her position in San Diego and accepted the one in Los Angeles primarily to be able to care for her mother."

Warren's new job included oversight of the Los Angeles Public Library's forty-six branches. At first, she missed San Diego and later recalled, "For almost a year it was hard for me to turn in each morning at the door of the Los Angeles Public Library. In San Diego the staff had been small and the atmosphere informal, with complete understanding among the staff members. In Los Angeles the library was much bigger and the atmosphere more stiff and formal." According to author Molly Manning, Warren's colleagues were motivated by her dedication and professionalism. "It was said that her coworkers were inspired to work as hard as she did while trying to emulate her personable manner."

After serving as first assistant city librarian for seven years, in 1933 Warren was promoted to the position of city librarian. Her appointment was particularly noteworthy because fewer than six women were heading large public libraries at the time. During her administration, Los Angeles was ranked among the nation's top cities in library usage. In 1941, she was identified by the American Library Association as "#1 in the field of Women Librarians" and took a four-month leave of absence to head the organization's National Defense Book Campaign. From 1943 to

1944, Warren served as American Library Association president, the first Californian to hold that position.

Warren retired from the Los Angeles Public Library in 1947, but she was not retired for long. Almost immediately, she began teaching at the University of Southern California Library School and later taught library science at the University of Michigan. After Warren's death at the age of seventy-two, her friend and biographer Martha Boaz wrote, "I remember the kindness of Althea Warren, her unchanging and powerful gaiety of spirit, the prodigal way in which she spent her time, money, and talent, strength, and life itself. I remember her exuberance and her affection. I remember her as a generous-minded woman whose high intelligence and great spirit have left a profound mark in the lives of those who knew her."

MOTHER ROSALIE CLIFTON HILL (1878–1964)

University of San Diego Founder

Mother Rosalie Hill founded the San Diego College for Women, a private, Catholic women's college and the first unit of the University of San Diego. She had a reputation for ensuring a sense of exquisite design and decided that the architecture of the college should be an adaptation of a Spanish Renaissance style. Mother Hill explained, "There are three things that are significant in education: beauty, truth, and goodness. But the only one that attracts people on sight is beauty. If beauty attracts people, they will come and find the truth and have goodness communicated to them by the kind of people here."

Rosalie Clifton Hill was born in Washington, D.C., and received her early education in private schools. In September 1896, when she was eighteen, Hill was sent to the Convent of the Sacred Heart near Montreal. After receiving her first taste of convent discipline, Hill implored her mother to be allowed to return home. Her request was denied. At the age of twenty-one, Hill decided to enter the Society of the Sacred Heart. After several years of teaching, she made her final vows of profession in France.

When Hall returned to the United States, she was assigned to Eden Hall, a school located near Philadelphia. She also taught in Providence, Rhode Island, and served as principal at the Convent of the Sacred Heart in Maplehurst, New York City. In 1921, she was assigned to be the superior of Maplehurst and six years later was named superior at Overbrook Convent

Mother Rosalie Clifton Hill (1878–1964), San Diego College for Women groundbreaking ceremony. Mother Rosalie Hill is the shorter nun on the far right. *Courtesy of the San Diego History Center.*

of the Sacred Heart in Philadelphia. It was there that she first inherited a building program and completed the construction of the Overbrook Chapel. According to her biographer, Helen McHugh, "the planning of the structure with the architect, the research in stylistic detail, and the inevitable delays while waiting for materials was an invaluable experience for her and would serve her well in the future."

In 1929, Mother Hill moved to Chicago, where she remained for seven years. While in Chicago, she directed negotiations concerning the building of the San Francisco College for Women. Mother Hill believed strongly in the power of beauty to attract the mind and heart to God. In a talk that she gave to alumnae of the Sacred Heart in 1939, she pointed out that Christian educators had carried on the mission of communicating God's truth, goodness and beauty for centuries. According to her biographer Helen McHugh, "This thinking surely explains why in all the houses which Mother Hill governed she planned that the students be surrounded by traces of the beautiful."

In 1937, Bishop Charles Buddy, the first bishop of San Diego, mentioned his desire to open a school in his diocese to Mother Hill. "You are my first choice and the first one to whom I confide this most important work," he stated. In a letter dated July 21, 1942, she replied, "It would seem to us an immense privilege to found there under your guidance and with your help the San Diego College for Women." Selection of an appropriate site took several more years. In 1945, the bishop invited Mother Hill to inspect a site located in Linda Vista. After the visit she wrote, "In the afternoon of Thursday, the sixteenth of August, His Excellency, Bishop Buddy came to take us to Linda Vista Heights.…A truly inspiring Linda Vista stretched before us.…All this loveliness is within the city limits of San Diego, in the northwest section of the city."

Mother Hill secured permission from her superiors in Rome to borrow the necessary funds to begin the university, and when asked what her security would be by visiting bankers who were negotiating the loan, she answered, "My word." After serious study, she decided that the architecture of the college for women should be an adaptation of a Spanish Renaissance style that reflected "the energy, expansiveness and exuberance" of Spain's age of discovery. According to her biographer Helen McHugh, Mother Hill believed that usefulness and efficiency were priorities but saw no reason why they should eclipse beauty, for it was no more expensive to build something beautiful than something ugly.

The project began to move forward when Mother Hill and two companions, Mother de León, the future treasurer of the College for Women, and Mother Aimee Rossi, the future dean, came to San Diego in 1946. Both Mother de León and Mother Hill made frequent visits to the site. On one occasion, a workman was installing the large carved front doors, and Mother Hill told him how to place them. He looked at her and commented, "Lady, you must expect these doors to last one hundred years." She replied, "My good man, I expect them to last three hundred years."

Mother Hill wanted the campus, which came to be known as Alcala Park, to be unrivaled in its beauty and intricate design. The Society of the Sacred Heart agreed with her sentiments and provided a $4 million endowment for the San Diego College for Women. The first chapter of the University of San Diego was written on May 1, 1948, when groundbreaking ceremonies were held atop the windswept Linda Vista mesa. The mayor of San Diego at the time, Harley Knox, turned the first shovel of earth, with Bishop Buddy, Mother Hill and a group of religious

and local dignitaries in attendance. The first classes were scheduled to begin on February 11, 1952, and thirty-three students enrolled. The San Diego College for Women's original furnishings included ornate crystal chandeliers, beautiful tapestries and a library.

Her next project, planning a chapel for the campus, consumed much of Mother Hill's time and energy for several years. While she was superior of the Convent of the Sacred Heart at Overbrook, Philadelphia, in 1928, she had the experience of bringing to completion a chapel of English Gothic design. On January 31, 1954, the initial ceremonies for the dedication of the San Diego chapel began. Those who have visited Founders Chapel in the years since its completion have marveled at its beauty. A letter written to Bishop Buddy and shared with Mother Hill by an early visitor to the campus described his impressions of the new buildings, especially the chapel. "I visited the noble College for Women of USD. Words fail me to express my appreciation: Whether the breathtaking beauty of its spacious halls and patios or the ancient beauty of its tapestries and furniture…one place in particular, I will remember—the College chapel—the richness—the sheer beauty—the quietness…all will be a great monument to those who conceived it and to those who enabled the dream to become a reality."

On July 5, 1961, Mother Hill, then eighty-three years old, received a letter from Rome stating that her successor had been named, Mother Lenore Mejia, former president of the San Francisco College for Women. In her retirement, she had more time for visits with friends and was available for those who came to the campus. According to her biographer, "all who met her were impressed by her gentleness, by a beautiful gift of joy, of communicating joy to the nuns, to the students, and to their parents." She had three years of quiet retirement at the San Diego College for Women, where she remained until her death in December 1964.

In 1954, the College for Men and the School of Law began classes, and in 1972, the colleges merged and formed the University of San Diego. USD is one of a few Catholic universities in the country not sponsored by a congregation or a diocese. The 180-acre campus now houses buildings that encompass more than two million square feet and offers bachelor's, master's and doctoral degree programs.

RUTH ALEXANDER (1905–1930)

Record-Setting Aviatrix

A memorable chapter of the history of San Diego, known in the 1920s and '30s as the "Air Capital of the West," was written by Ruth Alexander. In 1929, she set a new official altitude record for women flying light planes. She also was the first female glider instructor in the country and the first female aviator to successfully complete a three-country flight along the Pacific coast.

According to historian Richard Crawford, Alexander was born in Irving, Kansas, in 1905, the only child of a hardware store dealer and a schoolteacher. As a child, she dreamed of flying and surprised her mother by jumping from the top of a barn using an umbrella as a parachute. Fortunately, she was not hurt. When a barnstorming plane landed in a hayfield near her home, Alexander experienced her first flight and decided to pursue a career in aviation. After her unhappy marriage to Mac Alexander ended, at the age of twenty-four, she moved to San Diego and worked at a beauty shop where she later created a hairstyle called the "Aviation Bob."

In 1929, Alexander entered a "Queen of the Air" contest sponsored by a local newspaper that offered flying lessons as a prize. Although she didn't win, she learned to fly at the Ryan School of Aviation. Historian Crawford quotes an entry in her diary written at the time, "Whee! I was in the air today. Don't know whether I was alright [*sic*] or not but I was happy. I know I'll be able to learn." Alexander quickly earned her pilot's license and became the sixty-fifth licensed female pilot in the country. In November 1929, she celebrated her new credential by taking off from Lindbergh Field in a "Great Lakes biplane" and continued climbing to an altitude of 15,718 feet over San Diego. Her flight was recognized as a new official altitude for women in light planes.

After her record-breaking achievement, the rising star recalled, "I was all over the newspapers. People looked at me like I was something in a zoo." In 1930, a perfect glider flight from the slopes of Mount Soledad in La Jolla that lasted only two minutes and thirty-three and two-fifths seconds, qualified her for a glider license. In doing so, she followed Anne Morrow Lindbergh as the second woman in the United States to earn this distinction. As a result of her accomplishment, Alexander soon became the first female glider instructor in the country.

On July 4, 1930, Alexander set out to break her previous altitude record. After briefly losing consciousness at extreme altitudes, she established a new

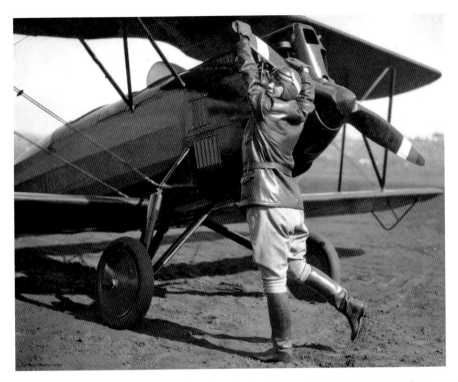

Ruth Alexander (1905–1930), record-setting aviatrix. *Courtesy of the San Diego History Center.*

world record of 26,600 feet at the apex of the flight in light planes for both men and women. The American record held prior to her flight was set by a man at an altitude of 24,074 feet over St. Louis, Missouri. According to historian Richard Crawford, the pioneering aviatrix later told reporters, "It didn't feel so good without any oxygen, so I drove down to about 7000 feet and then came down more slowly." The *Washington, D.C. Evening Star* headlined, "Unconscious girl rises 26,000 feet," and the *New York Times* proclaimed, "Sets Altitude Mark But Loses Her Senses."

Determined to set more records, Alexander's next goal was to complete a three-country flight beginning in Canada, crossing the United States and ending in Mexico. She began her flight in Vancouver, British Columbia and flew south. After flying nonstop for sixteen hours, on August 28, 1930, she landed at Agua Caliente in Tijuana and became the first female aviator to traverse the Pacific coast without touching land. Soon after completing her successful "three flags" flight, she attempted her next daring feat, a one-stop flight to the East Coast.

In the very early morning of September 18, 1930, Alexander readied her Barling light aircraft and began her transcontinental flight from San Diego's Lindbergh Field to New York. She planned to fly to historic Roosevelt Field on Long Island, and her only stop was to be in Wichita, Kansas. Before starting her flight, she joked with reporters and commented, "If I crack up, send me purple pansies: I like them best." The plane was heavily loaded with 117 gallons of fuel, and she took off from the airport into a thick marine layer of low clouds and fog that had developed overnight.

Only ten minutes after takeoff, she crashed nose first into a hillside in Point Loma, four miles north of the airport. Although there was no fire on impact, Alexander died instantly still strapped to her seat, and the remains of the plane were scattered over four hundred feet in Plumosa Park. Gary Fogel, author of *Wind and Wings: The History of Soaring in San Diego*, quoted a bystander's recollection of the event:

> *The crowd of friends who have risen at 2 a.m. is surprisingly large; and none of us will forget the happy self-confidence in Ruth's voice as she spoke of seeing her mother and father and of her joy that circumstances were permitting her to takeoff at this time.…She is off the ground easily. We watch the lights of the plane pass over the Marine Base, then the lights dim as she enters the fog, tho' for a moment more we can still hear the muffled tones of the motor: "If I can't get thru, I'll be back in fifteen minutes," she had said. We wait a full half hour and return home unknowing that even as we waited Ruth had crashed to her death on the north end of Point Loma.*

Newspapers all over the country carried news of the tragedy. However, the exact cause of the accident remained a mystery. San Diego's Board of Air Control concluded that the heavily loaded plane fell into a spin and struck the ground "with the motor full on." Investigators searching the aviatrix's room found a note to (and revealing that she had been married three months ago) Robert A. Elliott, naval reserve pilot: "If I have preceded you, do not grieve for me, but be content. Finish your work down here and make me proud of you.…And when you come, I will welcome you."

News of Ruth Alexander's death was particularly difficult for San Diego's glider pilots to bear, especially those associated with the Anne Lindbergh Gliders Club, an all-female glider club formed in 1929. Local glider clubs lost their enthusiasm for women's glider activities, and it would take several years before interest in gliding activities would again reach the fervor of early 1930.

Luisa Moreno (1907–1992)

Mexican American Civil Rights Leader

Luisa Moreno was a prominent leader of the Mexican American civil rights movement in San Diego. A major labor activist during the 1930s and 1940s, she formed the United Cannery, Agricultural, and Packing Workers Association (UCAPAW), a group that brought thousands of Mexican food-processing workers into the ranks of organized labor. Of the new members, 75 percent were women.

Born into an elite Guatemalan family, as a teenager Moreno moved to Mexico, where she worked as a journalist. In 1927, she married an artist, Angel De León, and the following year, she and her spouse moved to the United States and settled in New York City, where Moreno gave birth to her only child, a daughter. With the onset of the Great Depression in 1929, struggling to support her infant daughter and unemployed husband, Moreno found work as a sewing machine operator in Spanish Harlem. After becoming aware of the workers' poor conditions, she founded a Latina garment workers' union. This activity brought her to the attention of the American Federation of Labor (AFL), and she was hired as a professional organizer. Around 1935, Moreno left her abusive husband with her daughter in tow and moved to Florida, where she unionized African American and Hispanic cigar rollers.

She joined the Congress of Industrial Organizations (CIO) and became a representative of the United Cannery, Agricultural, Packing and Allied Workers of America (UCAPAWA). Moreno helped organize workers in pecan-shelling plants in San Antonio, Texas, and cannery workers in Los Angeles. In 1939, she was one of the main organizers of the Spanish-speaking Peoples' Congress, the first national Latino civil rights assembly. The conference was held in Los Angeles and attended by approximately 1,000 to 1,500 delegates representing over 120 organizations. Speakers addressed issues of jobs, housing, education, health and immigrant rights. According to Vicki Ruiz, author of *From Out of the Shadows: Mexican Women in Twentieth-Century America*, Luisa Moreno was the driving force for promoting the congress and "drew on her contacts with Latino Labor unions, mutual aid societies, and other grass-roots groups to ensure a truly national conference."

According to historians Carlos Larralde and Richard Griswold del Castillo, Luisa Moreno, who moved to San Diego in 1940 at the age of

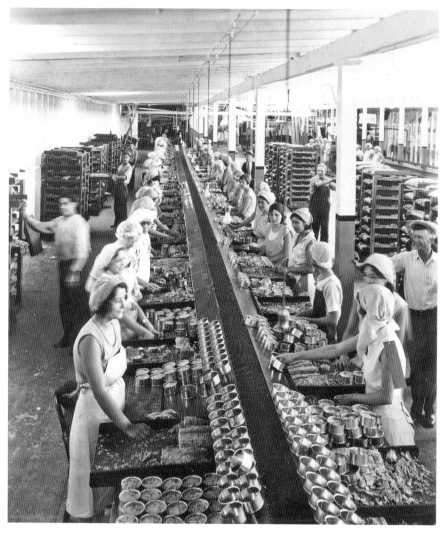

Luisa Moreno, an avid civil rights activist, formed the United Cannery, Agricultural, and Packing Workers Association (UCAPAW), a group that brought thousands of Mexican food-processing workers like these fish cannery employees into the ranks of organized labor. *Courtesy of the San Diego History Center.*

thirty-three, "radiated emotional strength and self-confidence." A friend described her as "a formidable and charismatic speaker in both English and Spanish. She wrote very well, and bilingually; she turned out the best written leaflets I've ever seen....She had a powerful fight for persuasion. She could convince others by the weight of her logic, her ease of words,

and her speaking abilities." As a union consultant, she organized hundreds of fish and cannery workers and urged employers in the largest San Diego canneries to not hire scab workers.

With the dawn of World War II, San Diego became a major center for the defense industry, and thousands of Mexicans crossed the border to meet the demand for workers. They were, however, not allowed to work in the petroleum industry, shipyards and other vital war industries. In 1940, Moreno was invited to speak before the American Committee for the Protection of the Foreign Born (ACPFB) and eloquently described the lives of migrant Mexican workers. She stated, "These people are not aliens. They have contributed their endurance, sacrifices, youth and labor to the Southwest. Indirectly they have paid more taxes than the stockholders of California's industrialized agriculture, the sugar companies and the large cotton interests, that operate or have operated with the labor of Mexican workers." Portions of her speech were reprinted in committee pamphlets and became part of her legacy.

As wartime stress mounted, racial tension increased, and tough police action against Hispanic youth gangs became common. "The Sleepy Lagoon murder" was a name used by Los Angeles newspapers to describe the death of a man who died near a swimming hole frequented by Mexican Americans. In response to the alleged murder, three hundred young Hispanics were arrested, and twenty-three were convicted. The trial became an important cause for Mexican American civil rights activists, and Moreno, together with others, formed the Sleepy Lagoon Defense Committee. The SLDC's mission was to mount a civil rights crusade so that the men might receive justice. Speaking out against race hatred toward Hispanic youth, she stated, "The Sleepy Lagoon Case is a reflection of the general reactionary drive against organized labor and minority problems. This case now sows all sorts of division among the various racial, national and religious groups among the workers." The convictions were ultimately reversed on appeal.

During the summer of 1943, a series of riots erupted in Los Angeles, largely directed by U.S. servicemen toward Mexican American youths and other ethnic minorities who dressed in "zoot suits," consisting of baggy, tight-cuffed pants and an oversized jacket with exaggeratedly broad padded shoulders. According to historians Larralde and Griswold del Castillo, "about two hundred sailors took the law into their own hands when they formed a brigade of twenty taxicabs and cruised through the Mexican section of town looking for Zoot-suiters. Wherever they found them, they jumped and beat

them up, often stripping them of their clothes." The riots lasted for more than a week and made headlines.

Luisa Moreno pointed out that the papers "insinuated that Mexicans were the cause of all the crime and delinquency in California," and she and other community leaders mobilized a committee on behalf of the youngsters. After about one hundred sailors and marines in San Diego chased youths wearing zoot-suit garb, Moreno pressed for a military investigation. Her actions outraged state senator Jack Tenney, chairman of a California un-American activities committee, and he accused her of participating in an anti-American communist conspiracy. Moreno responded, "A desperate Tenney has used the Sleepy Lagoon Case and Red-baiting to support segregation, oppose miscegenation, and to divide the Mexican community in Southern California."

Convinced that there were instances of unreported violence against Mexicans, Moreno commented, "We will never know much about the San Diego civilian casualties. The Navy and the local newspaper ignored the violence since the victims were Mexicans." In 1950, as a result of her outspoken criticism, Senator Tenney arranged to have her deported as a "dangerous alien." She and her second husband, Gray Bernis, who had served in the U.S. Navy, went to Mexico and later moved to her native Guatemala. She never again returned to the United States.

Luisa Moreno died on November 4, 1992. Her friend Bert Corona later stated, "Even to this date, I still emphasize how instrumental she was to the Chicano community during the 1930s and 1940s. Luisa Moreno's record is a whole chapter in Chicano history. As a major figure, she illustrated to us what dedication and discipline is while serving the community."

Madge Bradley (1904–2000)

San Diego's First Female Judge

Madge Bradley was appointed as San Diego's first female judge in 1953 and was the only woman on the bench in San Diego County until her retirement in 1971. Her pioneering career included numerous "firsts." She was the first woman on the board of directors of the San Diego Bar Association, the first San Diego County woman to be appointed to a state bar committee and the first woman ever to preside over San Diego's Municipal Court. The Madge Bradley Building of the San Diego County Superior Court is named in her honor.

Madge Bradley (1904–2000), first female judge in San Diego. *Courtesy of the San Diego History Center.*

Bradley was a first-generation American born in rural Ukiah, California. Her father, Hugh Bradley, was a law clerk in England before he immigrated and met her mother at an English settlement in Oceanside. After briefly trying grape farming in Mendocino County, the family returned to Oceanside when she was six years old. Bradley was the second oldest of five children. After

graduating from Oceanside-Carlsbad Union High School in 1922, she began working at the Union Title Insurance and Trust Company in San Diego.

It was at the title company that Bradley first came into contact with lawyers, prompting her to recall years later that "they were all rather smart and that perhaps if I studied law, I, too, could be smart." Bradley became fascinated with the law and began taking correspondence courses from La Salle Extension University in Chicago. Before going to work, she would awake early to study law and debate the material with her mother, whom she later called "her only classmate." In 1927, she was hired by the San Diego County clerk's office, where she assumed responsibility for passports and naturalization records.

In 1933, she passed the California bar exam and was admitted to practice on June 9, 1933. Because of financial pressures during the Great Depression, Bradley decided to keep her secure job at the clerk's office. Her widowed mother had lost most of her money, and it was up to Bradley to support the family. Consequently, she did not begin to practice law until 1940. After she received some money as the executor of a friend's will, she took a leave of absence from the clerk's office. She obtained her first position with a law firm helping clients prove their citizenship to qualify for defense plant jobs and assisting landlords to evict undesirable tenants.

In 1942, Bradley opened her own practice, specializing in adoptions, domestic relations, probate and guardianship work. In addition, she became involved in San Diego public affairs, particularly regarding adoption procedures. From 1947 to 1949, she served as chairperson of the first Community Welfare Council's Adoption Study Committee, which was instrumental in changing California adoption laws and making San Diego the first in the state to receive a license to operate an adoption agency. She also was a past president and active member of the local chapter of the Altrusa Club, an international service organization composed of executive and professional women.

Bradley's circle of friends included most of the few women practicing law in San Diego in the 1940s, and they created an informal network. In 1945, fifteen female attorneys were allowed to join the San Diego County Bar Association. From 1946 to 1948, Bradley served as the first female member of the association's board of directors. She was director of the San Diego Bar Association in the late 1940s and helped found the Lawyers Club, a group dedicated to helping female lawyers and judges. She was encouraged to submit an application for appointment to the San Diego County Municipal Court and, as a result of lobbying from business and professional women's

groups, was appointed by Governor Goodwin J. Knight in 1953, making her the first female judge in San Diego County.

Although she tended to downplay the prejudice she faced as a woman in her trailblazing position, Bradley had a tough time as the first and only woman on the bench for eighteen years. For years after she became a judge, some litigants and attorneys would ask for reassignment to another judge. One fellow judge treated her rudely, making it clear that he did not approve of women on the bench and purposefully held judicial meetings at San Diego's Grant Grill, where women were not allowed. Newspaper articles focused on her fashionable attire and hobbies as much as her legal accomplishments. Over time, however, she earned a reputation for being firm, fair and well liked. One lawyer who initially had been opposed to Bradley addressed her court at the end of his case, stating "I just wanted you to know that I was opposed to your appointment, and I have completely changed my mind." Her colleagues on the bench came to affectionately refer to her as their "den mother." Bradley was reelected three times uncontested before retiring on December 1, 1971. It would take fourteen months after she retired before Artie Henderson, the second female judge, was appointed to the San Diego bench.

Bradley continued her involvement in San Diego community activities and became the first chair of the Women's Division of the San Diego Traffic Safety Council. Over the years, she was bestowed with many honors from religious groups, service organizations and the legal community, including being named San Diego's Woman of the Year in 1953. In 2002, she was inducted into the San Diego County Women's Hall of Fame.

Bradley was an independent woman who never married. After her retirement, she pursued interests in travel, genealogy and antiques. She continued to be active with service organizations in San Diego, including the Lawyers Club. The Madge Bradley Building of the San Diego Superior Court is a reminder of her groundbreaking role as San Diego's first female judge. At the building's dedication, Bradley remarked, "I would like to accept this honor not only for myself, but for all women who have become judges since my time for they followed in my lone, tentative footsteps nearly fifty years ago." In 1999, after serving as the municipal court building, it became the Madge Bradley Family Court. Her biographer Laura Scher noted, "Ironically, the building is just blocks away from the Grant Grill, the venue of the weekly meetings of county judges, which refused to serve women when Bradley was appointed."

After suffering complications from a broken hip, Bradley passed away on March 22, 2000, at the age of ninety-five.

PART 3

1950–2000

When this era began, everything from America's legal system to its television programs reinforced the perception that women were the "weaker sex." They were not expected to act independently, have adventures of their own or compete with men for serious rewards. One pioneering San Diego woman who dared to compete in the world of sports was Florence Chadwick. Long before Title IX became federal law, she opened doors for women in athletics and gained lasting fame with channel swims around the globe.

As with many other pioneers, female physicians had to be determined and assertive to overcome cultural expectations. One woman who paved the way for those who came after her was Anita Figueredo, San Diego's first female surgeon. Medicine was only one of several passions in her life. She also successfully combined her medical career and family life. Figueredo was a well-known philanthropist and humanitarian who maintained a close friendship with Mother Teresa for four decades.

Drawing, painting and creating things came naturally to Martha Longenecker, and there was never a question that her career would be in the arts. Attracted by her work, in 1955 San Diego State University invited her to develop their ceramics program, and she spent thirty-five years as professor of art. In 1978, Longenecker founded the internationally acclaimed Mingei Museum of World Folk Art, dedicated to furthering the understanding of art of people from all cultures of the world.

Mingei Museum. *Courtesy of Mingei International Museum.*

While playing the piano at a corporate party in 1957, Joan Smith met Ray Kroc, owner of McDonald's fast-food chain, and they eventually married in 1969. Ray Kroc later purchased the San Diego Padres, and after his death in 1984, his widow inherited a huge fortune. Joan Kroc became one of San Diego's great philanthropists and donated millions of dollars during her lifetime. She will always be remembered as one of the most generous benefactors to causes that would help change people's lives.

The world's first fitness resort and spa, Rancho La Puerta, was founded by Deborah Szekely and her husband in a valley only an hour's drive from San Diego. Located in Tecate, Mexico, "The Ranch" as it has become known, is a destination that encompasses health and wellness for mind, body and spirit. Age has never been a factor in Szekely's life. In her nineties, she established WellnessWarrior.org, an online social media movement that gathers and shares news about health research and advocacy.

In 1875, after over one hundred years of unspeakable treatment of Native Americans, President Ulysses S. Grant set aside lands in San Diego County for exclusive use of the Sycuan Band of the Kumeyaay Nation. In 1972, Anna Sandoval, who was born on the reservation, became the first female tribal leader. She worked to improve the community's standard

of living, physical conditions and psychological well-being. Under her leadership, the tribe built a bingo hall that was later replaced by a vast casino. With the funds from the casino, Sandoval realized her dream of lifting her people out of poverty.

Beginning in the twentieth century, women filled the majority of primary school positions while men obtained the better-paying high school and administrative jobs. In 1993, Bertha Pendleton, a black woman, assumed the position of superintendent of San Diego City Schools. Pendleton advocated for equity in education and championed reform policies that influenced state education trends. She hosted President Clinton at a San Diego school where he signed the Goals 2000 into law and left a legacy of excellence.

Jeanne McAlister, a pioneer in recovery who continues to work at the age of eighty-three, has helped thousands of San Diegans overcome addiction. The McAlister Institute, founded in 1977, operates twenty-five programs throughout San Diego County that provide high-quality, low-cost substance abuse services and has earned recognition as one of the leading resources for compassionate care and treatment of individuals and families suffering from alcoholism, drug addiction and homelessness.

In 1963, Betty Friedan's book *The Feminine Mystique* ushered in the women's liberation movement. In 1970, only 3 percent of the nation's lawyers and 7 percent of doctors were female. There were 10 women in the 435-member House of Representatives and 1 in the U.S. senate. The belief that women would be able to successfully combine domestic life and a career was still very new.

FLORENCE CHADWICK (1918-1976)

Nautical Trailblazer

Florence Chadwick, a female pioneer in the field of long-distance swimming, is undoubtedly one of the most internationally known residents of San Diego. Famous for her rough-water swimming and fortitude, Chadwick was the first woman to swim across the English Channel in both directions, which she achieved in record time. She stunned the world with her repeatedly successful swimming feats as she traveled around the globe seeking new records to break. Chadwick accomplished these exploits through intense desire, raw ambition, innate talent and an affinity for the ocean.

Florence Chadwick (1918–1995), nautical trailblazer. *Courtesy of San Diego History Center.*

Born on November 9, 1917, to Mary Lacko and Richard Chadwick of San Diego, Florence Chadwick began swimming at the age of six and immediately felt a love for the water and especially the cold ocean environs of San Diego. At an early age, she developed a reputation as a long-distance expert. When she was only ten years old, she entered and won the contest to swim across the rough waters of San Diego Bay Channel, becoming the first child to achieve this. As she continued swimming, her proficiency, strength and endurance flourished. At the age of thirteen, Chadwick came in second at the U.S. national championships. During a span of eighteen years, she completed one of the most challenging swims in the nation at that time, the two-and-a-half-mile rough-water race in La Jolla, California, which she swam and won ten times.

With the encouragement of her parents, she devoted her time to becoming a star swimmer in the arena of long-distance competitive swimming. Her strengths were in distance and stamina; she never won a short-distance race in a pool. She tried out for the 1936 Olympic team but failed to qualify because all of the events were comparatively short lengths.

At Point Loma High School, Chadwick swam competitively, and after graduating in 1936, she attended San Diego State College and studied law at Southwestern University of Law in Los Angeles and Balboa Law School in San Diego. At one time, she considered law as a career, but instead returned to the water. She took another hiatus from competitive swimming during World War II when she produced and directed aquatic water events for the military. Along with Esther Williams, she appeared in aquatic entertainment shows and in the movie *Bathing Beauties*, one of Williams's Hollywood film productions. Although she married twice, she knew she could not sacrifice her competitive ambition for marriage, housekeeping and cooking. This was not the Florence Chadwick she strived to be.

In the late 1920s, Chadwick returned to swimming, this time with her long-held dream of crossing the English Channel, which was considered the greatest challenge by swimmers in that era. Her inspiration was Gertrude Ederle who, in 1926, was the first American and first woman to swim the Channel. It was common belief that no woman had the physical capability to swim this rough water, but Ederle beat the record set by a man by almost two hours.

Chadwick fervently wanted to surpass this remarkable feat by swimming both ways, from England to France and then France to England. In preparation for this arduous crossing, she relocated to Saudi Arabia to work as a comptometer for the Arabian American oil company Aramco and trained in the rough waters of the Persian Gulf. For two years, she swam twice a day and saved $5,000 for the entry fee to swim the English Channel. She felt physically and mentally prepared and in June 1950 resigned from her job and left for France to attempt her first Channel crossing. The London paper the *Daily Mail* was holding a contest to sponsor applicants who wanted to swim across the Channel, and Chadwick applied. However, no one at the paper knew who she was, and it rejected her application. Chadwick proceeded despite this setback and took a trial run in July at her own expense.

A month later, on August 8, 1950, Chadwick walked into cool water on Cape Griz-Nez, France, accompanied by a small boat with her father and two friends from Saudi Arabia who kept her occupied by writing Arabic jokes on a blackboard while her father fed her sugar cubes. Chadwick set a world record for the crossing, arriving in Dover, England, in thirteen hours and twenty minutes. This exceeded the twenty-four-year-old women's record, set by Gertrude Ederle, by one hour and eleven minutes. "I feel fine," Chadwick stated after finishing the swim. "I am quite prepared to swim back."

A year later, Chadwick returned to Dover, and in September 1951, despite strong headwinds and poor visibility, Chadwick decided to swim. The route across the Channel from Dover, England, to Sangatte, France, was significantly more demanding than the France-to-England route. Many swimmers would not take the challenge, and no female swimmer had ever finished it. Battling seasickness and fatigue, she managed to finish in record time to become the first woman to swim from England to France and the first woman to swim it both ways.

Chadwick arrived home to San Diego to a colorful ticker-tape parade but with very little money in the bank. Her personal investment in her training and the crossings had depleted her savings. Her fame, however, and the admiration that came with her record-breaking swimming performances brought opportunities for product endorsements and television and radio appearances.

In 1952, at the age of thirty-four, she made her initial attempt to become the first woman to swim a twenty-one-mile stretch between the coast in Southern California to the Catalina Islands. The water was exceptionally cold, and sharks were trailing her while the crew used rifles to keep them away. The entire country was watching this event on television, hour after hour. As she approached sixteen hours in the water, she suffered from exhaustion and hypothermia and had to stop swimming. Unbeknownst to her, she was only a half mile from the shore. She told a reporter, "Look, I'm not excusing myself, but if I could have seen land I know I could have made it." Two months later, she tried again. The fog was just as dense, but this time, she reached the California shore, breaking a twenty-seven-year-old record by more than two hours and becoming the first woman ever to complete the swim successfully.

Chadwick had more records to break and, on September 1953, swam the English Channel from England to France again, setting a new world record for both women and men. In the same year, she mastered the Straits of Gibraltar in a new record. She also crossed the Bosphorus between Europe and Asia both ways and then the Turkish Dardanelle—all within a few weeks. Not long after, she successfully swam the Bristol Channel between England and Wales. Determined to beat her personal best, in October 1955, she crossed the Channel from England to France in a smashing thirteen hours and fifty-five minutes!

One may think she was superwoman, and most times, she lived up to this reputation. However, she did experience some agonizing defeats, including attempting to cross the Irish Sea, which she tried on her last great swim in 1960. She could not overcome the forty-five-degree water.

After retiring from swimming, Chadwick worked as a stockbroker in San Diego and continued to coach young people and promote long-distance swimming. She later served as vice-president of the First Wall Street Corporation. She was the only female member on the San Diego Hall of Champions board. In 1970, she was inducted into the International Swimming Hall of Fame and in 1984 into the San Diego Hall of Champions. A few months later, she received the Living Legacy Award in San Diego. Chadwick passed away in San Diego in 1976 after a long battle with leukemia.

Often noted as the greatest female swimmer, Chadwick easily broke many records set by men, destroying the perception that women were incapable of long-distance swimming. Today, women hold numerous ultra-long-distance records in swimming and other sports. As one of the trailblazers, Chadwick helped to transform opinions about women as endurance swimmers and paved the way for others to follow.

Her love of the sea never diminished. "I am happiest when I am in the water," she once said. "Some people go for a walk; I go for a swim."

ANITA FIGUEREDO (1916–2010)

Trailblazing Surgeon

Anita Figueredo had a dream at the young age of five: to be a doctor. Her mother, Sarita Villegas, a courageous woman, believed in her daughter and moved to the United States to help that aspiration become a reality. She knew if they remained in Costa Rica, where they lived, her daughter's vision of becoming a physician could not happen. There were no female doctors, nor indeed was there even a medical school there. "It is unusual that I knew I wanted to be a doctor at such a young age, but that my mother would listen and make a whole life change based on the wishes of a 5-year-old is truly amazing," said Figueredo. "I understood clearly that if it weren't for her, I wouldn't be able to do what I was doing." Declaring her intention to practice medicine and following through is characteristic of this remarkable woman, who was resolute, determined and self-assured about everything she set out to accomplish. She was on a journey to achieving many "firsts" as a doctor, humanitarian and philanthropist.

Figueredo was born in 1916 in Costa Rica, where her father, Roberto Figueredo, was the most acclaimed Costa Rican athlete of his time.

After a brief marriage, Anita's parents divorced. Her grandfather was a venerated peace-loving general and her grandmother the daughter of a Bavarian physician and professor of the classics.

Soon after listening to her daughter speak about her desire to practice medicine, Sarita Villegas set sail on a steamer with her daughter and cousin and settled in Spanish Harlem. As Villegas came from a family of strong women, it did not seem unusual that she would forsake her comfortable, upper-middle-class life in Costa Rica for a new start in America with only twenty-four dollars and no friends to help her daughter chase her dream.

Mother and daughter both worked lengthy and demanding hours. Villegas

Anita Figueredo (1917–2010), trailblazing surgeon. *Courtesy of the Anita Figueredo family.*

labored in a sweatshop and took extra work into their home to support the household while her daughter attended school. At age seven, Figueredo attended boarding school in Upstate New York, and her mother visited on weekends. Mother and daughter had a tacit agreement; Villegas would work, and Figueredo, in turn, would study and get excellent grades.

As the years passed, Figueredo stayed focused on her studies. When she was fifteen, Barnard College offered her a full scholarship to study pre-med. As she was thinking about the offer, the admissions officer made a derisive comment about her high school that deeply offended her. The teachers and administrators at the high school had been very kind and supportive of her. She, therefore, rejected their offer and instead accepted a scholarship to Manhattanville College, which established a pre-med program exclusively for her.

After receiving her degree at age nineteen, Figueredo enrolled at Long Island Medical College, one of only four women in a class of one hundred. A great deal of prejudice against educating women as doctors still existed. Many believed it was a misuse of the money since women got married and left the profession. Too many also thought women lacked the intelligence, skills and confidence needed to be a successful physician. Figueredo proved

them wrong and graduated with honors. In the next six decades, she achieved many firsts for women in medicine.

While in medical school, she met her future husband, William Doyle, who was studying to be a pediatrician. At first glance, she knew he was the one she was going to marry. After graduation, Doyle went into the service, and it was during a three-day leave in 1942 when they married; they were together for fifty-seven years. For most female physicians at that time, World War II helped accelerate their careers. Of the nation's 160,000 male physicians, about 35,000 were serving their country. Institutions that would not have considered hiring women now had little other choice. Figueredo was the first female surgeon to complete a residency at Memorial Cancer Center in New York and one of the first female cancer surgeons in the United States.

After the war, Drs. Figueredo and Doyle settled in a home in La Jolla, where she set up her medical office. One of the county's first female surgeons, Figueredo was the first woman in San Diego to earn hospital operating privileges in 1948. It was fifteen years before another woman received the same opportunity. As the first female surgeon in San Diego County, she also was one of a few female physicians who became experts in the field of surgical oncology. When she was in the operating room completing a surgery, Figueredo was so petite that she had to stand on a small stool to help her reach her patients.

One of her biggest fans was Dr. Brent Eastman, her son-in-law and former chief medical officer at Scripps Health. "She was my first surgical partner and one of the best surgeons I ever practiced with….She had unlimited energy, was exceedingly brilliant and incredibly modest," Eastman said. Her methodology for treating cancer emphasized prevention and early detection and transformed the medical field's approach to this insidious disease in San Diego. Figueredo pioneered the use of regular Pap smear exams as a method for early detection of cervical cancer and "spoke out against smoking before it was fashionable," he noted. In 1949, Scripps Memorial Hospital granted her senior surgical privileges. Dr. Figueredo retired from the operating room in the mid-1970s but continued to see patients in her office until 1996, at the age of eighty.

Medicine was only one of several passions in Figueredo's life. She was a devoted wife and mother, a philanthropist and a humanitarian. With nine children, the Figueredo-Doyle home was a hectic and happy household. Very little could deter Figueredo, even pregnancy. As Dr. Eastman recalled, "She once walked straight from the OR to the maternity ward, where she gave birth and returned to make rounds on her patients the following morning."

A liberated feminist years before Betty Friedan penned *The Feminine Mystique* and Gloria Steinman founded the women's liberation movement, Figueredo was able to combine her medical career with her family life long before many would ever consider to do so.

Dr. Sarita Eastman, daughter of Dr. Figueredo, wrote a biography of her mother, *A Trail of Light: The Very Full Life of Dr. Anita Figueredo*, which was translated into Spanish in Costa Rica. "My mother always retained very strong ties to the family back in San Jose and spoke perfect Spanish all her life," said Dr. Eastman. "She was proud to be Latina, and as a physician, served a large Spanish-speaking population," Eastman related to the *La Prensa San Diego*.

Figueredo's humanitarian contributions were also extensive, and she had a perfect role model to emulate. In 1957, Dr. Figueredo wrote to Mother Teresa, and they began a personal correspondence. The two friends finally met in 1960, when Mother Teresa visited San Diego. Figueredo said she was unprepared for the experience. "It was like being in the hands of God," she said. This was the start of a four-decade-long friendship, during which time Figueredo and Mother Teresa traveled throughout the world serving the poor and needy. Mother Teresa gave the doctor the title the "Smiling Apostle of Charity." Figueredo was honored to be one of her intimate friends.

Figueredo convinced Mother Teresa to establish her mission in Tijuana, Mexico, which now serves as the world headquarters for Mother Teresa's Missionaries of Charity Fathers. Initially, it was established to serve the indigents in Tijuana. In 1982, Figueredo founded a charity of her own, Friends of the Poor, originally dedicated to helping the impoverished residents of Tijuana and San Diego; it has since expanded to other regions of Mexico, as well as Guatemala and Nigeria.

During her lifetime of service to others, many organizations recognized Figueredo for her humanitarian and philanthropic activities. She served in the American Cancer Society and was trustee of the La Jolla Town Council from 1956 to 1968. Figueredo was such a devout Catholic that Pope Pius XII awarded her the Papal Medal Pro Ecclesia in 1954. In the late 1950s, she was honored as San Diego's Woman of the Year and became a founding trustee of the San Diego College for Women (now known as the University of San Diego). In 1970, she was invested as a Lady of the Order of the Holy Sepulcher of Jerusalem and later was honored with the Grand Cross of the Order. In 1973, she was made a Regional Link of the Co-Workers of Mother Teresa in America, a support group to the Missionaries of Charity in Calcutta, India.

The Women's Museum of California inducted Dr. Figueredo into the 2015 Women's Hall of Fame. "Anita was the most loving mother to her nine children that you can imagine," Eastman said in the *La Prensa*. "We were all intensely proud of her while she was alive and are delighted that her extraordinary story will be heard by future generations through the San Diego Women's Hall of Fame."

Dr. Figueredo passed away in 2010 at the age of ninety-three, and the Dr. Anita Figueredo Buildings complex, the property where she lived and practiced medicine, has been designated a historic resource.

Martha Longenecker (1920–2013)

The Artisan: Equal Parts of Inspiration and Determination

A devotee of every art form and a genuine visionary, Martha Longenecker had an extraordinary life filled with the love of beautiful art and the diversity of cultures worldwide. Her career in art was multifaceted—an artisan, an educator, a historian and a founder of the world-class Balboa Park Mingei International Museum. Her life's mission was to promote the importance of art and its influence on the lives of people around the globe.

In her oral history with KPBS in 2012, Longenecker cites several words that defined her persona and shaped her personal and professional life. She credits her early childhood experiences, parents and teachers for molding her into the woman she was to become and uses the following descriptors as she describes herself:

Tactile—She loved to take in her surroundings, feel and touch things, anything. Recalling a time when she was about three, she touched her mother's talcum powder, wet it and made a ball out of it. The feeling of that little ball was thrilling to her, and looking back, she believes it was "a premonition she would be a potter."

Resilient—From every negative event Longenecker bounced back, taking a lesson with her. A teacher once characterized Longenecker and other students as "dumb," and she recalls being perplexed because "[the comment] didn't make me feel dumb; it made me feel like what's wrong with her?"

Creative—She attributes her creativity and freedom to express herself to her brilliant kindergarten teacher, who gave her the confidence to create her personal designs without worrying about being judged. She notes

Martha Longenecker (1920–2013), the artisan. *Courtesy of Mingei International Museum.*

this special teacher "was enabling in every way and responsible for my creativity and confidence."

Confident—She grew up in a loving, cultured environment, in a family grounded in positive thinking, and the encouragement and support she received formed the basis of how she managed her life and her creativity.

Born in Oklahoma in 1920 to a fine Philadelphia Quaker family, Longenecker was proud that her great-great-great-grandmother was Betsy Ross. Interestingly, many members of her family had a "tactile" history of working with real materials and transforming them into everyday, useful products. To her good fortune, Longenecker inherited this exceptional talent to create extraordinary pieces with her hands.

The Longenecker family moved to California when Martha was an infant. Her father had practiced law but left the profession prior to their move. A principled gentleman, he was uncomfortable with the policies employed in the practice of law and felt it was against his Quaker upbringing. A talented inventor, he worked wonders with his hands, building and creating numerous projects, including their two-story home. Her mother, an educator, worked as a principal in the Los Angeles school system during the Depression, and to her credit, their family life was abundant with music and a love for culture and arts. One sister had an exceptional musical talent and a voice that was pitch perfect. Longenecker adored painting and noted, "If I didn't get a pencil box for Christmas, it was chaos, they'd have to go get it." From an early age, Longenecker planned to study drawing and painting when she went to college.

After high school, Longenecker attended Pasadena Junior College and then entered the Arts Studies Program at UCLA. It was here that she received her introduction to the art of pottery from renowned teacher and artist craftsman Laura Andreson. Longenecker was mesmerized by Palestinian, pre-Colombian, Japanese and Chinese pottery. It was not just "this is what you do with this clay. It was this art of pottery-making of the world," Longenecker said. After receiving a bachelor of arts, she attended Claremont Graduate School, where she studied painting with famed California artist Millard Sheets and received an art education credential and a master of fine arts degree. The art education credential was a nod to her parents, who wanted her to have a profession to support herself, which at times she did need. She believed she was finally on the path to achieving her dream of a career in fine arts.

World War II arrived, and Longenecker married her beau and had her first son. Millard Sheets had taken them under his wing, and they moved into a small guesthouse on his property in Claremont California. Very soon, her husband was drafted and sent overseas. With the help of Sheets and his wife, Mary, Longenecker set up a small pottery area at the cottage, creating wheel-thrown stoneware forms that were exhibited nationally through the prestigious Dalzell Hatfield Galleries in Los Angeles and New York from

1944 to 1964. Although she was a newcomer to the art form, the gallery chose to exhibit and sell her work along with only one other potter, a testament to her creative talent.

Longenecker was immediately taken with the beauty and uniqueness of Japanese poetry. In the summer of 1952, she had an experience that she says was "totally life-changing." She attended a weeklong seminar led by Dr. Soetsu Yanagi, an art historian, aesthetician and the founder of the mingei folk art movement in Japan, which was devoted to handmade objects that were exquisite and practical. Yanagi coined the term *mingei*—art of the people. Also participating were Japanese potter Shoji Hamada and the English potter Bernard Leach, who, as part of a world tour, lectured and demonstrated pottery making to area craftsmen. They invited her to visit them in Japan to experience the country's ancient craft tradition. Ten years later, she made the trip.

Longenecker was so enthralled with their mission that she gave up painting. Sheets's daughter, Carolyn Owen-Towle, who maintained a close relationship with Longenecker, said, "It was not just the work they made and how beautiful it was, but also their philosophy. It changed everything for her."

In 1955, San Diego State University asked Longenecker to develop the school's ceramics program, and it was an opportunity she could not decline. During her thirty-five-year tenure as professor of art, she taught the history of ceramics and design, directed the gallery program and supervised the university's student art teachers. Her initial classroom was bare, but with much ingenuity, she transformed it into a wondrous ceramic studio. Very quickly, the one class became two classes and then three. The program grew along with Longenecker.

Six years later, she was eligible to apply for a sabbatical, which she unexpectedly received and went to study in Japan. The four-month stay in Japan gave her the opportunity to directly experience the teachings of Dr. Yanagi and observe and work at the kilns of Shoji Hamada and Tatsuzo Shimaoka. Each was later named a National Treasure of Japan.

After her visit to Japan, Longenecker extended an invitation to Hamada and Shimaoka to lecture, exhibit and demonstrate pottery making. As she returned again and again to Japan for further study, she was inspired to develop an organization to initiate these cultural exchanges. With the help of her second husband, Martin Roth, she established the nonprofit Mingei International organization in the United States in 1974 to present lectures and exhibitions and promote the tenets of the movement. Four years later,

University Town Center and Ernest W. Hahn and Associates gifted her with a twenty-year leasehold, and in 1978, Longenecker opened the Mingei International Museum at University Towne Center in San Diego.

In 1996, the museum relocated to a forty-one-thousand-square-foot site on the Plaza de Panama in Balboa Park that included six exhibition galleries, a multimedia education center, a theater and an international art reference library. During her twenty-seven-year tenure as director (1978–2005), Longenecker directed the organization and design of 128 vibrant, exhibitions of "arts of the people," drawing from Mingei International's permanent collection and other museum and private collections. She also oversaw the production of exhibition documentary publications and broadcast-quality videos, which broadened the influence of the museum's mission worldwide.

Following her retirement as director in October 2005, Longenecker oversaw the development of a digital image database of nearly five thousand images from the museum's permanent collection and continued to serve as an active member of the museum's board of trustees. The museum still thrives and currently houses more than twenty thousand objects from 141 countries. "The pots were to eat from, the textiles were meant to be worn," said Longenecker's cousin Ana Smythe. "This was not art that would just be put up on a wall and stay there."

Longenecker's last book, *Mingei of Japan: The Legacy of the Founders—Soetsu Yanagi, Shoji Hamada, Kanjiro Kawai*, a retrospective of the work and legacy of the founders of the Mingei Association in Japan and the Museum's collection, was published by the museum in August 2006. San Diego State University honored Longenecker in 1998 with its Distinguished Service Medal and in 2007 with an honorary doctorate of fine arts degree. In recognition of her contribution to transcultural artistic understanding, in 2003, she was awarded the Order of the Rising Sun by the Emperor of Japan.

"It's important that man not only make but continue to use objects that are an expression of the total human being—mind, body and soul," Longenecker said. She was acknowledged as a genius who established a museum distinct in its dedication to the art of daily life, a museum that highlights objects made by the many for the many rather than by the few for the few.

Martha Longenecker died on October 29, 2013, at the age of ninety-three. She had a stroke while sitting at her desk stuffing envelopes with invitation to an event for her newly created the Mingei Legacy Resource Foundation.

JOAN KROC (1928-2003)

Cultural Bridge Builder

Joan Kroc, an unconventional philanthropist, dreamed big and expected exceptional outcomes from the charities to which she was so generous. Before giving a major $1.5 billion gift to the Salvation Army, she encouraged, "Think big, bigger than you've ever thought before." Kroc was a role model as a successful businessperson with a social consciousness and fierce determination. Her philanthropic arms reached diverse organizations, and she had a deep passion for helping people and enriching communities. Kroc's affluence grew from the service sector—fast-food sales in billions of dollars. Husband Ray Kroc was a billionaire entrepreneur and founder of the McDonald's Corporation.

Nicknamed "St. Joan of the Arches" by her close friends, Kroc was a quiet giver. Even though she was one of our nation's great philanthropists and donated hundreds of millions during her lifetime, she often preferred to contribute her gifts anonymously and eschewed publicity. Kroc gave away billions of dollars to causes she believed in, from hospice care to peace advocacy and providing children with safe places to play. Her vision was to re-create impoverished communities and transform them into neighborhoods where children would thrive and achieve upward mobility.

Born in 1929 during the Great Depression, Joan Beverly Kroc was the daughter of a railway worker and a former concert violinist. Soon after her birth, her father lost his railroad job, and the family struggled to maintain a normal family life under difficult economic circumstances. Music was a central part of her mother's life, and she always managed to provide piano lessons for Kroc. By the time she was fifteen, Joan Kroc was teaching a class of thirty-eight students and able to earn money to help her family. She continued teaching piano professionally as a means to support herself. Whenever she spoke about her childhood, Kroc often used "humble" to describe her upbringing and said she was just a plain Midwest girl.

In 1945, she met and married Rawland F. Smith, a navy veteran who eventually became a McDonald's franchisee. The couple's only child, a daughter named Linda, was born the following year. Kroc continued to teach piano and played at local supper clubs in St. Paul, Minnesota. While entertaining, she met Ray Kroc, who was attending a McDonald's corporate party. It was 1957 and only two years since Kroc had opened his first McDonald's franchise. Since they were both married, they carried on a

Joan Kroc (1928–2003), cultural bridge builder. *Courtesy of the Joan Kroc family.*

secret relationship for several years, though it eventually ended. Joan Smith and Ray Kroc reconnected in 1969, divorced their spouses and married. It was his third marriage and her second. Ray Kroc said in his autobiography that he "was stunned by her blond beauty."

Not long after, the Krocs moved to San Diego, and Ray Kroc purchased the Padres baseball team in 1974. Joan Kroc, not knowing much about baseball, initially questioned why he would buy a monastery. Ray Kroc generously shared his wealth by establishing the Kroc Foundation, which supported research on diabetes, arthritis and multiple sclerosis. He advocated for his franchisees to get involved in their communities. Perhaps his best-known charitable enterprise is the Ronald McDonald House, which provides living space for families at no cost while their children receive medical treatment.

Joan Kroc's initial philanthropic ventures began in 1976, when she founded an alcoholic education center. Ray Kroc had struggled with alcohol, and she had a deep personal interest in providing more services. Many of her friends have acknowledged she was never happier than when she was helping charities and other worthy organizations accomplish their missions. After Ray Kroc passed away in 1984, Kroc became a billionaire and gave charitably to causes for which she had a personal connection. Two years later, she founded Ronald McDonald House Charities, to which she has given more than $100 million in memory of Ray Kroc, a strong advocate for children.

Upon the death of her husband, Kroc inherited the San Diego Padres, stepped in and took control of the organization. As the Padres owner, she started Major League Baseball's first employee-assistance program for players and staff with drug problems. In 1990, she sold the team to TV producer Tom Werner and his partners.

An article in the *Washington Post* in 2004 suggested Kroc engaged in "a seemingly whimsical redistribution of treasure after the death of her husband." At times, she may have done things on impulse, but when it came to major gifting, she did her research and personally selected her funding positions. If you requested funding from Joan Kroc, you did not get it. Kroc had her individual ideas about giving, which she would get from a lecture, a newspaper story or a conversation, but it had to be meaningful for her and charities that were receiving the donation.

Peace and nuclear disarmament were among the first causes Kroc financed after her husband died. "I fear that President Reagan shares with the Moral Majority the belief that Armageddon is near," she told the *Los Angeles Times*

in 1985. "I just think it's time to quit this b.s. People are frightened and they just feel powerless, and I'm trying to tell them that they're not."

"She was very concerned about finding alternatives to conflict and violence," said Scott Appleby, director of the Joan B. Kroc Institute for International Peace Studies at the University of Notre Dame. "She was worried that otherwise our future would be bleak."

Although a registered independent, it was common for her to support liberal candidates. She donated $1 million to the Democratic Party's presidential campaign in 1987 hoping to elect a Democrat after eight years of a Republican administration. Her real interest was not politics, however, but education and identifying "the root causes of conflict and how to reorient our attitudes," said Appleby. Her $6 million contribution to establish the institute at Notre Dame was typical of her spontaneous approach to deciding how to use her fortune. In April 1987, the Reverend Theodore Hesburgh, former president of the University of Notre Dame gave a lecture in San Diego about how to educate students to be peacemakers in the nuclear age. Joan Kroc sat in the audience in rapt attention. At the conclusion of the speech, she walked up and said, "I am going to help," and six months later, they received a check. She never even introduced herself.

This unconventional philanthropist distributed her fortune the way "the non-rich fantasize it should be done: no fanfare or foundations, no red tape or robber baron formality." Quietly she would bequeath her fortune, giving away more than $1 billion toward various causes, including homelessness, nuclear disarmament, the arts and animal welfare, to name a few of her favorites.

Kroc did not adhere to the foundation concept of philanthropy. She defied tradition by giving enormous sums. "She's basically saying, 'Look, rather than creating a foundation to guard my assets and spend them wisely, I'm going to give them to the organizations that have proven themselves to me over the years,'" says Paul C. Light, a scholar of nonprofits at New York University. "That's a wonderful, gracious gift of confidence to those organizations that is quite rare today." It was her charitable philosophy that a foundation consumes the wealth of an estate in administrative costs and delays until tomorrow much of the good it could do today.

Her intention was to remain in the background but give generously. Three and a half months after being diagnosed with brain cancer, Joan Kroc died in October 2003. It was then that her wealth and generosity became known to the world. It was revealed she had just donated $2 billion to charity, including $1.5 billion to the Salvation Army, one of the largest gifts in the

nation's history, to build twenty-five to thirty community centers across the United States in hopes of transforming blighted neighborhoods; $200 million to National Public Radio, the largest gift ever to a cultural institution; and $50 million to found a peace institute at the University of San Diego. Millions more went to a variety of San Diego organizations, including the opera, the zoo and the local public radio affiliate.

After Kroc's bequests to charity and an undisclosed sum to her family (which includes her daughter, granddaughters and great-grandchildren), the proceeds from McDonald's would not be distributed. However, Joan Kroc will always be remembered in the annals of philanthropy as one of the wealthiest and most generous benefactors to causes that would help change people's lives. For Joan Kroc, philanthropy was deeply personal. "She did things her way, not for recognition or other considerations, but because it was the right thing to do," said former Padre Tony Gwyn.

Deborah Szekely (1922–present)

Godmother of the Wellness Movement

Meet Deborah Szekely, who exclaimed to the *Huff Post 50* when she entered her tenth decade of life, "I can't be 90!…My schedule is the same as it was when I was 60!" And, yes it was. Szekely, a quintessential visionary recognized as the pioneer godmother of the modern-day mind/body/spirit fitness movement, faithfully practices what she espouses. In 1940, Deborah and her husband, philosopher and health visionary Edmond Bordeaux Szekely, founded Rancho La Puerta, the original destination spa. In 1958, Szekely, on her own, opened the Golden Door, a smaller luxury property in northern San Diego County,

Szekely was born in Brooklyn in May 1922 to exceptionally unconventional immigrant parents: Rebecca and Harry Shainman. Her mother was a nurse and vice-president of the New York Vegetarian Society, and her father was in the garment industry. At her mother's insistence, the family was vegetarian and consumed mostly raw fruits, vegetables and nuts. Frustrated by the lack of fresh produce in the city, her mother arrived home one day and announced they were moving to Tahiti. She had already purchased steamship tickets. The year was 1926.

In Tahiti, her family met "the professor," as he would later come to be known: Edmond Szekely, a scholar working for the French government.

Deborah Szekely (1922–present), godmother of the wellness movement. *Courtesy of Deborah Szekely.*

Szekely specialized in studying the beliefs and living practices of early civilizations and sought "ways to apply natural living to an increasingly unnatural culture." He called the great cities, such as New York and London, "stone colossuses" and was researching the health-giving aspects of living in the South Pacific.

The professor became close with the Shainman family. After their return to the United States in 1934, they spent subsequent summers at various health camps run by Szekely in California and Mexico.

At sixteen, Deborah Szekely became his camp secretary, and they married when she was seventeen, just as World War II was about to begin. The professor, a Jew whose passport was from Romania, received a letter ordering him to report for duty and join that country's Nazi-sympathetic military. Such a return home would be a death sentence, so he ignored this mandate. Another soon arrived from U.S. Immigration Services, however, warning that he would be arrested as a deserter and deported if found in the United States. In 1939, the couple loaded all their worldly belongings into a car and crossed into Mexico. Today, they would be called "undocumented aliens." This experience led Deborah to

champion immigrant rights and cross-border cultural and environmental programs throughout her life.

The Szekelys found a small rancho to lease in a remote valley near Tecate, Baja California, only three miles from an equally remote border crossing between the United States and Mexico, about forty miles east of downtown San Diego. By June 1940, they welcomed their first guests to a health and exercise camp where the accommodations were primitive—no electricity or running water, no gyms or swimming pool and no guest rooms. They charged guests $17.50 a week and told them to "bring your own tent." Most guests worked in the vegetable garden two hours a day, which was one of the first intentionally "organic" gardens in North America. Europeans and a number of key people from Hollywood frequented the ranch, and the Szekelys hosted some war refugees who stayed for months or more, allowing them to maintain some financial stability. "In many ways it was more like a commune," Szekely noted.

This site matured into today's luxurious Rancho La Puerta on three thousand family-owned acres. The Ranch's philosophy has not changed since the beginning. Its goal is to make healthy people healthier. To quote the Ranch brochure, "We also have the same motto: *siempre mejor* or always better." Under Szekely's leadership, the Ranch was always changing, exploring, innovating. After seventy-five years, Rancho La Puerta's rate of returning guests is as high as 70 percent in many weeks.

The success of Rancho La Puerta and her own drive to continually create and innovate inspired Szekely to open a second health spa in Escondido, California. She named it the Golden Door, and it was initially located in a converted motel. Her concept of building a Japanese-style country inn was an immediate sensation, and the property's luxurious serenity, as well as its complete fitness program and delicious spa cuisine, attracted the wealthy and famous Hollywood elite. Today, both spas continually win top "best spa" awards from prestigious travel publications and have inspired destination spas throughout the globe.

True to her title as doyenne of the post–World War II fitness movement, Szekely introduced such ideas as hiring exercise instructors with backgrounds in modern dance and gymnastics. She also introduced yoga classes, which were unfamiliar to many guests. All activities were part of her pioneer concept called the "Fitness Day," during which guests chose from several fitness classes or other activities on the hour and interspersed vigorous workouts with soothing treatments or quieter pursuits, such as stretching.

Szekely sold the Golden Door in 1998 but almost immediately had seller's remorse and tried to repurchase it, to no avail. For many years, she remained in a creative design capacity to successive owners while also giving an evening presentation to the guests at least once a week. During the many years she was running both businesses, Szekely had two children: a son, Alex (who passed away from melanoma in 2002), and a daughter, Sarah Livia Brightwood, to whom she handed over control of Rancho La Puerta in 2011.

Undoubtedly, Szekely is a driving force, a powerhouse of energy, dedication and determination. Throughout the decades, her work and interests broadened into many areas. As she noted in an interview with the *Atlantic Monthly*, she "changes course and careers every decade." Although never having held a public office, Szekely decided to run for Congress in 1982. She lost the race but moved to Washington, D.C., and entered a new chapter in her life—public service on a national and international level.

Her first project following her defeat was to conceive and launch "Setting Course: A Congressional Management Guide," which continues as the comprehensive training and reference manual for newly elected senators and Congress members. She decided to write this after she learned that new members of Congress had no real reference regarding how to set up and run their office in the Capitol.

In 1984, President Reagan appointed her president of the Inter-American Foundation (IAF), an independent foreign assistance agency of the U.S. government, which supports grass-roots development in Latin America and the Caribbean by awarding grants directly to the organized poor. She led the organization until 1990. In 1991, she founded Eureka Communities, a national training program for CEOs and leaders of nonprofit organizations dedicated to CEO mentoring, teamwork and building bridges.

Age was never a factor in Szekely's many careers, and as she approached her ninetieth birthday, she embarked on another inspirational venture: WellnessWarrior.org, an online social-media movement to foster happier, healthier lives for Americans via the prevention of illness, as well as pressuring Congress and corporations to ensure that our nation's food, water and farmlands are free of chemicals.

Recipient of the Orden Mexicana del Águila Azteca (Order of the Aztec Eagle), the highest honor Mexico can bestow on a citizen of another country, Szekely has always held a deep interest in immigrant affairs and policy. She founded the New Americans Museum at Liberty Station, San Diego, to share and honor the stories of post–World War II immigrants through today. Its mission reads, "A catalyst for celebration of America's past and promise,

the Museum provides inspiring educational and cultural programs to honor our diverse immigrant experiences."

Equal parts activist and entrepreneur, Deborah Szekely credits volunteerism as the impetus for her growth and international influence. She has never forgotten that San Diego is her home and has been especially involved in community service. She was named "Mrs. San Diego" by San Diego Rotary—the first woman so honored. Her volunteer efforts have been widely recognized by scores of other awards, on both sides of the international border, and her philanthropy work has helped raise millions. Additionally, Szekely was the first woman in California and the fifth woman in the nation to receive the Small Business Administration Award. Today, she is on the board of Center for Science in the Public Interest. Her two honorary doctorates are from San Diego State University and the California School of Professional Psychology, currently Alliant University.

In an interview with Gail Sheehy, Szekely noted, "I am not ready to be thought of as really 90. It is just a number. I have as much passion and ambition as I have had at any age, and the same stamina and energy I had when I was 60"—a fact she attributes to her lifelong attention to a healthy diet and exercise. "Never stop learning, meditating and climbing mountains, and always look for meaningful ways to give back!" is her advice to all.

Anna Sandoval (1934–2010)

First Woman Sycuan Tribal Leader

Anna Prieto Sandoval was an inimitable woman who lived her childhood in abject poverty and perceived hopelessness. In spite of the many challenges, she evolved into a leader of strength, determination and fortitude. She transformed an entire community and changed thousands of lives for members of the Sycuan Band of Mission Indians. At the time Sandoval assumed leadership in 1972, there were approximately eighty members living on the reservation near El Cajón, California. Their living area was composed of decrepit wooden shacks with no indoor plumbing, a concrete-block meeting hall and a century-old Catholic church. Most tribal members had no steady work and were barely surviving.

A 1991 *Los Angeles Times* article, "Tribe Hits Jackpot with Its Gambling Operation," described Sandoval's rise to power from impoverishment. She recalled the nadir of her life when, as a single mother of five children on

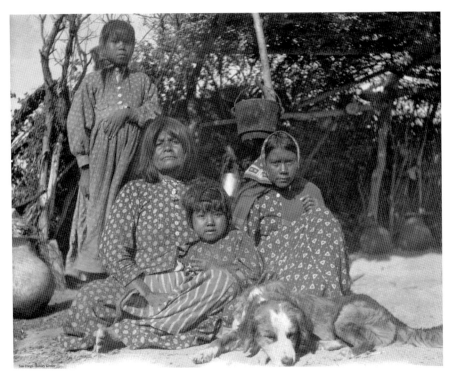

A Native American woman and her children. *Courtesy of the San Diego History Center.*

welfare, she walked ten miles to El Cajón looking for milk. "Passing the wooden shacks with outhouses on the rocky hillsides of her reservation, she prayed for deliverance of her people," the article stated. She recalled asking God, "What can you do to help us?" Her answer was yet to come.

Sandoval was born on May 14, 1934, on the Sycuan Band of the Kumeyaay Nation Reservation, which had also been the birthplace of her mother, Ada Prieto, and four generations before her. The Kumeyaay language was her primary language and English her second. As a child, she attended Dehesa Elementary and then Grossmont High School in El Cajón. Her first marriage, which occurred in 1953, ended in divorce; she later remarried. After raising her children, Sandoval attended Grossmont College and later taught the Kumeyaay language at San Diego State University.

In addition to being the first female tribal leader, she was responsible for building the first bingo hall on the reservation. Under her leadership, the tribe opened the Sycuan Bingo Palace in 1983. The thriving hall outgrew the demand and in 1990 was replaced by a vast casino. With the funds from

the casino, the community was able to build a much-needed clinic, a fire station house for tribe families and a new church. This progress and financial stability was a source of pride for this once impoverished reservation. Getting to that point was not an easy journey. Sandoval was an innovative Indian leader at the beginning of the gaming movement and struggled to persuade the tribal council that bingo was good for the tribe.

From the moment she became chairwoman of the Sycuan tribe in 1972, she worked to improve her community's standard of living, physical housing conditions and psychological well-being. She instilled hope and paved the way for a prosperous future. Sandoval was able to bring jobs, housing and a new way of life to her people and her community. She sought to provide health benefits to all native peoples and, even more importantly, to assist her larger community in becoming self-sufficient.

When Pan American International, a company that ran one of the first Seminole bingo halls in Florida, proposed a bingo hall in 1983, some tribal members, worried about traffic congestion and strangers on their lands, objected. So Sandoval said, "We can put it on my land," as noted in the *Los Angeles Times* in 1991. The land for the bingo hall was selected such that 91 percent of it would fall on Sandoval's property. In the early days, Sandoval rolled tortillas in her kitchen and sold them to bingo players. She later said it took years of persistence and "yards of paperwork" to open the bingo hall.

Initially, the bingo hall was not producing the 55 percent of the net the tribe was promised, and there was a good deal of complaining from the tribal members. It was a difficult time for Sandoval, being on the receiving end of the criticism. Then in 1987, Sycuan took control, asked Pan Am to leave the property and found the company in violation of a tribal licensing ordinance. A court case ensued, and the tribe won $300,000, which it distributed among tribal members.

Under direct control of the Sycuan tribe, the bingo hall saw revenue grow and profit soar. In 1990, an ornate 68,000-square-foot casino stood in place of the original the bingo hall. In 2000, the voters of California passed Proposition 1-A, and following this vote, the California Constitution was amended to permit Indian gaming on Indian reservations. The Sycuan signed a tribal gaming compact with the State of California, and in November 2000, the Sycuan opened a state-of-the-art 305,000-square-foot casino. Eventually, the Sycuan Band also became one of the largest employers in San Diego County. All the members of the band shared in the profits. Sycuan gaming revenues helped both the Sycuan tribal members and the broader East County community. The tribe was generous and,

throughout the years, has supported many local charities and area schools. Gaming profits later enabled the tribe to invest in the purchase of the Singing Hills golf course and hotel, now called the Sycuan Resort.

Anna Sandoval achieved her dream of lifting her people out of poverty. Unemployment, which was pervasive prior to gaming, disappeared, and the Sycuan Band of the Kumeyaay Nation grew to be one of the wealthiest tribes in the United States. In turn, Sandoval also enjoyed the riches of prosperity and became one of the most affluent Native Americans in California. She enjoyed her large house, her Cadillac and the accessories that went with her newfound wealth.

However, she never forgot her roots. She stayed grounded in her culture and native history, focused on creating awareness and instilling values of life in all Kumeyaay. As a tribal elder, she became a champion for preserving the Kumeyaay language and culture and helped found a class to teach younger generations their native language. Sandoval had traditional Kumeyaay lines tattooed on her face and encouraged tribal members to follow cultural traditions. In 1990, under her guidance, Sycuan convened its first powwow, which has since grown to be one of the largest held in California.

As the years passed and the wealth accumulated, Sandoval looked at this transformation and often spoke about some regrets. She voiced that not all changes were for the good of her people and opined that the reservation had become "a little Las Vegas." In a 1994 interview with the *San Diego Union-Tribune*, she complained the kids don't have hardships, noting that even eighteen-year-olds were given their own houses. "I guess it's good in a way, but when you lose your traditions, you don't know who you are, what you are. All they know is what's mine."

In 1991, she lost reelection as head of the tribal council by a mere three votes, which she attributed to her tendency to be a trifle overbearing. During her twenty years as leader, however, the Sycuan rose from despair and poverty to become a national model of tribal self-sufficiency, a transformation that Sandoval was largely responsible for.

Viejas former chairman Anthony Pico called Sandoval "a very bold person but also very sensitive," the *Union-Tribune* reported. He praised her vision in leading Sycuan to be the first local tribe to establish gaming, an example followed by other tribes. "Because of her, we enjoy a better life."

As a member of the Sycuan Band of the Kumeyaay Nation, Anna Sandoval was a mentor, matriarch and inspiration to many women both in her native community and throughout San Diego County. At her induction into the San Diego Women's Hall of Fame, she noted, "Our people need

to understand the importance of honoring our ancestors and our traditions and to never forget the hardship and depravation our people went through to get where we are today."

Anna Prieto Sandoval died of complications of diabetes at her home on the Sycuan Band Reservation on October 28, 2010, at the age of seventy-six. She was survived by three sons, Joseph, Raymond and Orlando; fifteen grandchildren; and five great-grandchildren. After she died, most of her personal possessions were burned in accordance with the Sycuan belief that she would need them for her journey to the next world.

BERTHA PENDLETON (1933–PRESENT)

First Black Superintendent in San Diego

Throughout the history of education in the United States, women have always been noted for outstanding teaching skills and for possessing the qualities necessary to nurture children through their developmental years. They led the one-room schoolhouses, and as the cities grew and education institutions with them, they assumed administrative and leadership positions—that is, until more men entered the educational ranks. Women remained the teachers, and men assumed the administrative positions. At the time Bertha Pendleton assumed the position of superintendent of schools of San Diego, only 5.7 percent of superintendents throughout the country were women. Of that number, only 4 percent of the superintendents were black women. However, 80 percent of the teaching and office staff were women.

In Pendleton, the leaders in the San Diego school system recognized a gifted teacher and leader. Her mentors, including Dr. Tom Payzant, Reverend George Walker Smith, Mercedes Richie and Dr. Jack Stone, identified her as administrative quality and encouraged her to reach high on the academic administrative ladder. She met Dr. Gorge Walker Smith very soon after she moved to San Diego, and a forty-year friendship ensued. She rose through the ranks, starting in 1957 as a seventh and eighth grade math teacher, and eventually reached the top administrative position in 1993, where she remained for six productive years.

Bertha Pendleton was born in Troy, Alabama, in 1933; grew up in the small town of Gadsden; and attended a segregated school district. According to a *Heart of San Diego* interview in 1999, she was surrounded by a large extended family that supported and encouraged her to grow up

Under Bertha Pendleton's leadership, San Diego schools flourished. *Courtesy of the San Diego History Center.*

in what they believed "was the right way." Her parents were religious and very kind people, and she and her younger sibling grew up in a loving, supportive environment. In her words, "she led a sheltered life." In high school, she would probably have been considered a "nerd" in today's terminology, she noted. Her dream was to be a doctor; however, there were no counselors to guide her, and she felt overwhelmed getting through the process. That led her to think about education, which was another subject she had thought about pursuing. She realized most of her heroes were teachers and thought, Why not follow their example?

Limited by financial circumstances, she had to go to a school she could afford. When she was accepted by Knoxville College and offered a $250 scholarship, it was not a difficult decision. Knoxville was a small Presbyterian school, and she was well suited to the environment. In 1954, she graduated with a degree in biology and moved with her husband, whom she met in college, to Chattanooga, Tennessee, where she began her first teaching assignment, a third grade class. Several years later, Pendleton heard that San Diego was recruiting teachers, so she attended an interview and was immediately hired. When she decided to relocate to San Diego with her husband and young son, "My

family thought I was going to the end of the world," she said with a smile. That was 1957.

Her first San Diego assignment was teaching seventh and eighth grade math at Memorial Junior High School. At the same time, she attended San Diego State University, taking a course to get certification. It was the 1956–57 school year, and Pendleton felt very comfortable in the multi-ethnic student population of Hispanic, black and white students.

She rose through the district's ranks as a school counselor, local coordinator of compensatory education and high school principal. When she moved to the central office in 1976, she was director of compensatory education, then assistant superintendent and, for about eight years, Superintendent Tom Payzant's second-in-command. In 1993, Payzant left to become assistant secretary of elementary and secondary education in the U.S. Education Department. His was a hard act to follow after fourteen successful years in San Diego. The district looked no further than Pendleton, who was deputy superintendent, and, in one decisive vote, selected her to run the district.

Bertha Pendleton was the first woman and the first black person to be named to the top post in the 127,000-student district, which in 1993 was the eighth largest in the country. The selection of Pendleton was the polar opposite of how other large urban districts were choosing their new leaders in that year. Other districts, including Chicago and New York, conducted far-reaching and sometimes divisive national searches that became intertwined in the politics of race.

Undoubtedly, San Diego had chosen a winner. Pendleton had been recruited for the top posts in several other districts, including San Francisco and San Jose, California, before she accepted the job in June 1993. The fact that Pendleton was in such demand is perhaps one reason the board found it unnecessary to do a nationwide search for "new blood."

The district appeared to be on a successful academic track. Therefore, a veteran like Pendleton was a natural choice and most skilled to continue on course. After the selection, most board members said they believed she shared their desire to continue moving from the old "factory'" model of schooling to a performance-based system. "If you want to change, it makes sense to look for someone from the outside. However, there is real merit in getting someone who can just move with" an agenda, Pendleton says. "It wasn't like I was trying to come in and turn the ship around."

Pendleton made improving student achievement the cornerstone of her plan for the district. She advocated for equity in education and championed reform policies that influenced state education trends. Some of her notable

achievements included augmenting reading programs, reducing class size in primary grades, enforcing a rigorous accountability approach and establishing zero-tolerance policies toward violence throughout the district. Pendleton led a statewide task force on reading and instituted a Reading Recovery Program in San Diego schools. During her tenure, fourteen schools were opened to alleviate overcrowded urban areas.

A combination of Pendleton's rapid reform efforts and an unfortunate economic downturn led to a bitter five-day walkout by the teachers in 1996. During this difficult period, Pendleton worked feverishly with the teachers and the union to negotiate a new contract, which resulted in a collaborative, interest-based relationship between the teachers and administrators and improved the working environment.

Pendleton was educated at Knoxville College, San Diego State University and United States International University and earned her doctorate in educational leadership at the University of San Diego in 1989. She hosted two visits by President Bill Clinton, including a visit in 2000 when he signed the Goals 2000: Educate America Act into law. Pendleton was a member of the National Science Foundation, the McKenzie Group, the American Association of School Administrators–Urban Schools Committee, the Association of California School Administrators and the San Diego Association of Administrative Women in Education. She was a founder of the Association of African American Educators. Now a retired consultant, Pendleton continues volunteer efforts in education.

JEANNE MCALISTER (1932–PRESENT)

Savior of Thousands

Jeanne McAlister personally understands the pain, loss of hope and helplessness of the thousands of people she has interacted with for the past forty years. She was in their shoes six decades ago. To escape from her dysfunctional family, she ran away from home and began drinking at the age of fourteen. McAlister eventually returned home to San Diego, and when she was only fifteen, she married, had a baby and then divorced her husband.

To drown her pain and unhappiness, she used alcohol as a panacea and became an alcoholic. In her own words, she "felt like she was in a tunnel, and it was getting narrower." Her blackouts were frequent and loss of

memory common; consumed by total despair, she attempted suicide twice. "I kept doing things I was ashamed of." In an interview with the *San Diego Downtown News*, McAlister reminisced on that defining time in her life. "I was going to some pretty dark places and it was against my nature." By the age of twenty-four, deeply embarrassed about whom she had become, she somehow managed to attend an Alcoholics Anonymous meeting. It was a struggle. Other participants did not take her seriously since it was not commonly accepted that a person of her age could become an alcoholic. However, she persevered and, for the next fifteen years, remained sober and employed.

Jeanne McAlister (1932–present), savior of thousands. *Courtesy of Jeanne McAlister.*

Through a normal progression of soul searching, she eventually entered therapy, seeking a deeper understanding of who is Jeanne McAlister. During this period, the "human potential movement" was coming to the forefront, and McAlister realized how comfortable she felt with the philosophy of the program. It was a movement in psychology that includes group therapy, encounter groups and primal therapy and was based on Gestalt psychology, a type of therapy popular in the '70s, aimed at self-realization. Furthermore, she discovered within herself an intense desire to help people who were feeling the anguish she experienced many years before. As she became more deeply involved with the movement, she decided to conduct small therapy groups for people with alcohol and drug addiction.

In 1977, McAlister met a psychiatrist who recognized that people with personal experience were more effective working with alcohol and drug abusers than professionally trained people. He offered McAlister a position as program director coordinating his therapy programs for abusers. It was not long before the doctor realized working with the San Diego County was too stifling for him, and he ended the partnership. For McAlister this was not the end but the beginning. Twenty years into her sobriety, Jeanne McAlister founded the McAlister Institute and assumed the position of chief operation officer. Fortunately, the dedicated staff that had been

running the program with her were determined to move forward and remained with her.

Thirty-eight years later, McAlister has seen many changes. In addition to providing drug and alcohol services at low cost for the impoverished, the institute also serves persons with mental illness. McAlister understood early on that mental illness is prevalent among abusers and treating one without the other does not provide the optimum chances for recovery. The institute now offers residential programs, outpatient for adults and three adolescent social model detox facilities, which are not available anywhere else in California.

McAlister Institute provides services for more than 2,500 men, women, children and teens each month in San Diego County with twenty-seven different programs offering inpatient, outpatient and vocational services. A very specialized program, the Kiva Women and Children's Learning Center, works exclusively with mothers and their children. It is a long-term residential program (six to twelve months) for substance-abusing women and their children. The first program in the county to help pregnant mothers to stop using drugs so their children would be healthy and "born free" was developed by the institute. The clients receive assessments; attend educational workshops covering vocational training, life skills, health and relapse prevention; and receive individual and group counseling, treatment planning and, very importantly, parenting instruction.

The primary focus for the McAlister Institute is drug and alcohol addiction for people of all ages, but it also provides sexual harassment assistance, transitional housing, halfway houses for returning prisoners, services to the deaf and training for other organizations. Facilities are located in Oceanside, South Bay, Lemon Grove and other areas throughout the county, and plans are being considered for building a treatment campus and consolidating some programs all in one place.

In interview with the *San Diego Downtown News*, McAlister spoke about how easily accessible drugs are: "The work we do hasn't changed. Recovery and treatment begin with compassion, dedication, and commitment to lifestyle changes. It involves learning to make good life decisions, retooling of drug-related and dependent paradigms, modifying behavior, increasing self-awareness, and understanding the complexity of the disease of addiction… and a lifetime commitment." She noted that hundreds of thousands of individuals suffering from addiction have "passed through the doors of McAlister Institute, and not one of them—not one—has chosen to become an addict, any more than a person chooses to contract cancer or heart disease." The institute has earned recognition as one of San Diego County's

leading resources for the compassionate care and treatment of individuals and families suffering from addiction and homelessness.

McAlister has always advocated for responsive services tailored for individual needs, and in 1972, as an advisor to the Superior Court in San Diego, she developed model programs for substance abuse recovery services that have been widely replicated. Many of the local educational institutions often request her to speak to their students and staff, and her work as an advocate in this field has opened doors to speak throughout the country. She has conducted seminars and workshops nationally and internationally. McAlister has over two thousand hours of advanced professional training and is a State Certified Substance Abuse Counselor. In 2010, she received the coveted San Diego County Mental Health Person of the year award.

Now eighty-three years old, she is celebrating fifty-eight years of recovery. Asked about any plans to retire, and why she continues to work, "It keeps me young. I have no concept of retirement, no dreams for another life. My life is a dream, and I live it." Her dedication to helping women and children and to strengthening families merges with her life's focus to serve the disadvantaged, neglected and needy among us.

2000–2015

By the dawn of the twenty-first century, everything had changed. Cultural stereotypes and assumptions that previously deprived women of their independence and power were shattered. They could now serve as university presidents, legislative leaders and even police chiefs. The six remarkable women profiled in this era were pioneers in the educational, civic and social life of San Diego. They exemplify strong role models who shared a more expansive vision of what a woman can accomplish and made significant contributions to the history and culture of the city.

When Lynn Schenk enrolled in law school at the University of San Diego in the late 1960s, there were only three women in her class. Seeking employment after graduation was a challenge because the San Diego private law firms had a policy not to hire women. In 1976, Schenk became involved in politics when she was awarded a White House Fellow position as a special advisor to the vice president. In 1993, she became the first California congresswoman to be elected from south of Los Angeles. After leaving Congress, Schenk served in a variety of positions in the California state government, and as the first female chief of staff, she served Governor Gray Davis from 1999 to 2003. Throughout her life, Lynn Schenk has worked tirelessly toward achieving justice and equality for women.

The first woman to be appointed as chancellor of the University of California–San Diego, Marye Anne Fox, is also an internationally renowned scientist and 2010 recipient of the National Medal of Science. Under her leadership, UCSD completed a $1 billion capital campaign and expanded

California State Capitol. *Courtesy of Dreamstime LLC.*

at an unprecedented pace to accommodate increasing numbers of students and a billion-dollar research enterprise. Fox has been a role model for girls and young women who aspire to have a career in science.

Shirley Weber is the first African American from south of Los Angeles to be elected to the California state legislature. She assumed office in 2012 and was reelected by a wide margin in 2014. A former professor of Africana studies at San Diego State University, she helped to establish that department in 1972 and taught there for forty years. Under her leadership, the department developed a national reputation as one of the strongest Africana studies programs in the country.

Up until recent years, the idea of female rabbis would have seemed farfetched. Traditionally, a rabbi was an observant Jewish male who knew Jewish law, resolved disputes and instructed the community. Consequently, it is not surprising that Lenore Bohm, who dreamt of becoming a rabbi, was counseled, "You do not want to be a rabbi; you want to be a rabbi's wife and president of Sisterhood." Determined to purse her choice of career, in 1982, she became part of the first wave of female rabbis in the United States and was hired as assistant rabbi at Congregation Beth Israel, becoming the first female rabbi in San Diego County.

Ever since the founding of police departments in the United States, policing has been viewed by most people as a traditionally male occupation, and men still are the overwhelming majority of police officers. Although female police chiefs are still a vast minority, after thirty-one years of service, Shelley Zimmerman rose through the ranks and was promoted to the position of San Diego Chief of Police in 2014. Although the job of big-city police chief is daunting, Zimmerman has met the challenge and made great progress in gaining the trust of her fellow police officers as well as the residents of San Diego.

The first lawmaker from San Diego to be elevated to the top leadership post Speaker of the California State Assembly, Toni Atkins, was unanimously elected in January 2014. She is the third woman and first acknowledged lesbian to occupy that position. Atkins previously was a member of the San Diego City Council and, following resignation of the mayor in 2005, became acting mayor. She is a coalition builder who believes government policies can improve people's lives and a powerful advocate for women, veterans and homeless people.

The remarkable women whose accomplishments are highlighted in this era have been at the core of change and innovation. Their spirit, determination and creativity embody the character of San Diego, known as "America's Finest City."

LYNN SCHENK (1945-PRESENT)

Tireless Advocate for Justice and Equality

Schenk remembers growing up with a keen sense of how much justice and equality contribute to the fabric of a community. This awareness led her to aspire to be an attorney. She enrolled in law school at the University of San Diego in the late 1960s. What she encountered there was something not contemplated on this journey to serve her community—blatant discrimination, especially from her professors. In an interview, Schenk relayed the story of how her property class professor asked her, "Why are you in this law school taking the place of a man who has to earn a living and support his family? You would be better off learning to fix the dishwater and iron so you could save your future husband some money." There were only three women in her class, but it was Schenk who challenged the discrimination they encountered at school. One of her victories was to insist the school install female bathrooms at several convenient locations on campus. That this discrimination still existed almost one hundred years after Clara Shortridge Foltz was sworn in as the first female lawyer in California illustrates the powerful stigma Schenk and her female lawyer friends faced as young attorneys.

Involved in the political scene for most of her professional career, Schenk has often remarked, "Everything is political," including her decision to enter the legal profession. She made up her mind despite her high school counselor's admonishment that girls are not lawyers and should learn to type to prepare for a secretarial job. With her parents' strong support, she ignored that advice.

The daughter of working-class Hungarian immigrants, Schenk was born in 1945 in the Bronx, New York. Her father, Sidney Schenk, was a Holocaust survivor, and her mother, Elsa, arrived on one of the last ships to the United States before Jews were no longer welcomed. Both lost numerous close relatives and friends. Schenk's parents struggled to support and educate her and her brother, Fred. In their household, English was not spoken, and Schenk did not speak the language until first grade.

Schenk attended the Beth Jacobs School for Girls of the East Bronx. She earned a bachelor of arts from the University of California–Los Angeles in 1967, and three years later, she received her juris doctorate from the University of San Diego Law School. Schenk was one of the first women to be admitted to the law school. During 1970–71, she studied international

Lynn Schenk (1945–present), tireless women's advocate. *Courtesy of Lynn Schenk.*

law at the London School of Economics and then returned to San Diego. In 1972, Schenk married University of San Diego law professor C. Hugh Friedman.

Seeking employment after law school was a challenge for Schenk and her female colleagues because the San Diego private law firms had a policy not to hire female lawyers. Not welcomed in the profession, they looked to the public sector for employment. Schenk's first position was with the San Diego office of the state attorney general. Employment, however, was not the only obstacle Schenk and her professional female associates had to conquer.

In 1971, Schenk and two other female lawyers challenged the Grant Grill's refusal to permit female lunch guests between noon and three o'clock in the afternoon. The Grant Grill was the "power lunch" spot for judges, lawyers and politicians. They devised a plan and asked a male friend to make a reservation under his name. At the scheduled time, the women marched unescorted into the restaurant but were refused service. After exhorting them to leave to no avail, the staff finally seated them to loud booing from the male patrons. The three continued to return until a "Gentlemen only until 3:00 pm" sign was permanently removed. While this has become a watershed moment in San Diego feminist history, it was only one of many discriminatory issues women faced that Schenk hoped to resolve.

Eager to help in the community, she and several female attorneys volunteered to join committees of the San Diego Bar Association. They were denied; no women were wanted. Soon after, Schenk and her female colleagues formed the Lawyers Club of San Diego in 1972. Their purpose was to advance the status of women in the legal profession and focus on the barriers women faced in San Diego and the state. Their goal was to change the laws.

Gender inequality was imbedded throughout society. Women were not permitted to register to vote in their own name. For example, voter registration forms required Schenk to choose between Mrs. Schenk

Friedman, her husband's last name, or Miss Schenk, even though she was married. Married women were not allowed to manage or control their community property, hold credit cards in their own name or have a business line of credit without a male cosigner. Of course, women could not be policemen, firemen or utility pole climbers.

To rid society of these injustices, Schenk went after the banking sector. It was obvious that women were deliberately being prevented from independently entering the business world. Men wanted to retain their financial power and, thus, the status quo. "If you were going to start a business, and you went to the bank, you couldn't get a loan without a male signer," Schenk noted in a May 2015 article in the *Jewish Journal*. For many, including Schenk, this was an indignity. Along with several other women, including Dr. Anna Figueredo, another subject in this book, Schenk founded the Women's Bank of San Diego, the first California bank owned and operated by women. She said she formed a bank "where women would be looked at for their credit worthiness, not their sex."

Over the next twenty years, Schenk held numerous prestigious positions. After working in the San Diego office of the attorney general, she was hired by the San Diego Gas and Electric Company, the company's the first female attorney. She worked there from 1972 to 1976. Her involvement in politics began in 1976, when she was awarded a White House Fellowship and was selected as a special assistant to the vice president, working for both Vice Presidents Nelson Rockefeller and Walter Mondale. Governor Jerry Brown appointed her deputy secretary of the California Business, Transportation and Housing Agency. Schenk held this position from 1977 to 1980, when Brown selected her to become the first female secretary of that agency, serving for three years. Upon her return to San Diego, Schenk entered private law practice and was appointed to several public company boards of directors However, she kept her hand in the political scene. Schenk served as the California co-chair for the presidential campaign of Michael Dukakis in 1988 and was appointed to the San Diego unified port district where she served as a commissioner and vice-chair from 1990 to 1993 and advocated strongly for environmental protection policies.

In the annals of gender equality, the 1992 elections made history and were coined "Year of the Woman." The number of women in Congress doubled from twenty-four to forty-eight. Schenk made her own history as the first California congresswoman to be elected from south of Los Angeles. She served the Forty-Ninth Congressional District from 1993 to 1995. Due to her strong credentials as an environmentalist, she earned

seats on the Energy and Commerce and the Merchant Marine and Fisheries Committees. As noted in the History, Arts and Archives of the House of Representatives, "Congresswoman Schenk focused much of her congressional career on balancing her interest in protecting the environment with tending to the business interests of her constituents." She was a proponent of the Clean Air Act, pushed for stronger pollution control and advocated to establish wildlife refuges in her district. However, she also supported business interests of biotechnology and other tech sectors by encouraging development through tax incentives, and of course, she always pushed for women's rights.

One of her most notable accomplishments began in the 1980s, when she proposed to Governor Brown the concept of the high-speed rail network connecting Northern and Southern California. While a congresswoman, Schenk wrote the bill that had the first five high-speed rail corridors in the country, including California. She is proud to be considered the "mother of high-speed rail in California."

After leaving Congress, Schenk served in a variety of positions in the California state government and has the distinction of being the first female chief of staff to a California governor. She served Governor Gray Davis in this capacity from 1999 to 2004 and oversaw the operations of state government.

For the past forty years, Schenk has been extremely involved in the San Diego community as an advocate and civic volunteer and has served on numerous boards and commissions, including the Red Cross and San Diego Symphony. She is a recipient of numerous honors and awards, including San Diego Women's Hall of Fame inductee, the Scientists' Recognition Award from the Scripps Institution of Oceanography in 2011 and the San Diego Corporate Directors Forum Lifetime Achievement Award in 2012.

Schenk is a director of Biogen, a trustee of the Scripps Research Institute, a member of the California High-Speed Rail Authority, a board member of Sempra Energy, a trustee of the University of California–San Diego Foundation and a member of the University of San Diego School of Law Board of Visitors.

Throughout her life, Schenk has worked to achieve justice and equality for women through a variety of different paths, empowering women politically, professionally and financially. She is, indeed, a remarkable woman!

MARYE ANNE FOX (1947–PRESENT)

Chancellor and Renowned Scientist

It was in 2010 that Marye Anne Fox, one of the nation's most creative physical organic chemists and seventh chancellor of the University of California–San Diego was awarded the National Medal of Science, the highest honor bestowed by the U.S. government on scientists, engineers and inventors. This is a prestigious reward and one well deserved by a brilliant scientist who has devoted her life's work to science and education. "Chancellor Fox's contributions to the field of chemistry stand out on their own, yet they are matched by her academic leadership. Either would be an accomplishment, but to excel in both realms is truly remarkable," said Mark Thiemens, dean of the Division of Physical Sciences at UC–San Diego.

The first woman to be appointed as permanent chancellor in the University of San Diego system, Fox assembled a distinguished team of senior academic leaders whose achievements raised the ranking of UCSD with awards of Nobel and Pulitzer Prizes. When Fox arrived at UC–San Diego in August 2004, she vowed to increase the school's standing by developing its three pillars of strength: innovation and discovery, interdisciplinary scholarship and international leadership. She committed to preparing the next generation of eminent scientists and innovators through advancing STEM (science, technology, engineering and mathematics) education.

Born in 1947 in Canton, Ohio, Fox received her bachelor of science from Notre Dame College and her doctorate from Dartmouth College, both in chemistry. She has also received honorary degrees from twelve institutions in the United States and abroad. In an interview for the Chemical Heritage Foundation, she spoke about the times in her life she had to make key decisions about her career path. Fox credits much of her success to her mentor in graduate school who encouraged her to continue pursuing her degree when she became pregnant with her first child. He fully supported her and counseled it was possible to balance science and a family. Her parents preferred she stay home and take of the baby and not continue her education. On track to get her doctorate in three years, Fox was reluctant to change her degree schedule and decided to remain in school. Throughout her career, Fox maintained this balance and was proud her five sons were able to share in her accomplishments. She and her first husband have three sons, and with her second marriage to chemistry professor James K.

Marye Anne Fox (1947–present), chancellor and renowned scientist. *Courtesy of University of California–San Diego.*

Whitesell, she has two stepsons. To this day, her husband, children and many grandchildren are central in her life.

After graduate school, Fox embarked on a distinguished university teaching career. In 1976, she joined the faculty of the University of Texas at Austin after completing a postdoctoral appointment at the University of Maryland. The University of Texas magazine named her "Best of University of Texas Natural Science Faculty." In 1986, she won the Teaching Excellence Award and in 1996 received Sigma Xi's Monie A. Ferst Award in recognition of outstanding mentoring of graduate students. Fox was a professor at the University of Texas for twenty-two years and held the Waggoner Regents Chair in Chemistry. She was then appointed chancellor and distinguished professor of chemistry at North Carolina State University, a post she held from 1998 to 2004. It was 2004 when UCSD tapped her as chancellor and distinguished chemistry professor.

During her tenure as chancellor, the university launched innovative research and partnership endeavors to expand and strengthen international collaboration, successfully reached a $1 billion campaign goal, expanded academic and campus programs and facilities and received national and international recognition in prominent university rankings. A large physical expansion took place under her leadership, with the inception or completion of more than $3.5 billion in enhancements, including an enlarged student center and new classroom and laboratory space.

Increasing the diversity of the students attending the school and cultivating more partnerships within the private sector was another critical objective Fox pledged to implement. To accomplish this, she made sweeping modifications in leadership, public prominence and funding to enhance diversity on campus. All undergraduates were required to complete a diversity course, and Fox mandated diversity commemorations for minority populations be expanded. She also led the campus to become one of the greenest in the nation, and it is now a "living laboratory for climate change research and solution" and self-generates 84 percent of the power necessary to function from nonrenewable natural gas.

Her tenure was one of immense growth with both tributes and trials. Under her guidance, UCSD emerged as a leadership powerhouse. At times, she struggled with budgetary issues, rising student fees and periods of racial tension. When she announced her retirement in 2012, she noted, "The average tenure of a chancellor or president is 4.5 years, and I'll have been here eight next June....There's always a time for new leadership."

Fox resumed the position of distinguished chemistry professor and was thrilled to be going back to teaching and research. At the time of her announcement, UC president Mark Yudof said that Fox "added striking breadth and depth to the university's already sterling reputation. The accomplishments of her service give renewed energy and purpose to the institution and set a visionary course for the 21st Century."

In addition to her exemplary teaching and academic leadership talent, Fox did outstanding research and published broadly in organic photochemistry and electrochemistry. She received international research awards in Spain, Holland, Germany and Russia and was cited by *Esquire* magazine as "Best of the New Generation." Her work has applications in materials science, solar energy conversion and environmental chemistry. Fox has held over fifty endowed lectureships both nationally and internationally and published more than four hundred scientific articles.

Throughout her career, she was elected to memberships in elite science organizations, including the National Academy of Sciences and the American Philosophical Society, and to fellowships in both the American Academy of Arts and Sciences and the American Association for the Advancement of Science. Her awards are too numerous to list, but some of the more esteemed include the American Chemical Society, the Garvan Award, Southwest Regional Award and Arthur C. Cope Scholar. Additionally, she has been a Sloan Research Fellow and a Dreyfus Teacher Scholar and was named by the New York Academy of Sciences in 1999 as an Outstanding Woman in Science.

In addition to being a nationally renowned chemist, academic leader, teacher and researcher, Fox was and still is an active participant in a plethora of organizations, councils and academic and community boards. These include numerous scientific advisory boards, university-associated boards at UCSD and North Caroline State, many nonprofit boards and foundations and editorial advisory boards. Her awards, citations and recognitions number in the hundreds.

Marye Anne Fox is a role model and paradigm to the many young girls and women who aspire to have a career in science. She admits she could not have done this on her own and attributes her good fortune to others: "I was very blessed to have people who cared about me and about my career."

SHIRLEY WEBER (1948–PRESENT)

Founder of Africana Studies at SDSU

Surmounting barriers and overcoming challenges have always been a way of life for women, but for African Americans it has been especially difficult. Shirley Nash Weber is an ideal example how with determination, intelligence and familial support, women can climb the ladder of obstacles and never look down. Professor, school board member, state legislator, international academic lecturer and community leader are only a few words that describe what Dr. Weber has accomplished.

It all began with her educational achievements. Born in 1948 in Hope, Arkansas, to sharecropper parents, Weber has resided in California since the age of three. She and her seven siblings grew up in public housing in a poor section of Los Angeles and were educated in inner-city public schools. In a 2008 San Diego State University oral history project, Weber recalled the positive influence her elementary school teachers had on her future. She noted, "All of our teachers were black at the school, and they all had a deep, deep, abiding commitment to the kids in the projects because they understood what our challenges would be being born black and being born poor. We would have to be excellent they told us that every day. 'You must be excellent, because without it, you will not survive.'" That is exactly what Weber did. She excelled.

Although her father left school at the sixth grade level, he continually encouraged his children to excel. He often said he would "drink muddy water or sleep in a hollowed-out log to make sure his kids received a good education."

Weber graduated high school with honors and entered the University of California–Los Angeles, where she received her bachelor's, master's and doctorate degrees. Attending a college of such diversity was a completely new experience. She described it as a "culture shock." Weber noted it "felt like I spoke a foreign language." At the time she entered UCLA, there were fewer than three hundred African Americans at the graduate and undergraduate level out of thirty thousand students. While a student, she worked as a caseworker for the Episcopal City Mission Society, serving the aged and indigent. Prior to receiving her doctorate in the area of speech communications, Weber taught at California State University at Los Angeles and Los Angeles City College. She then joined the faculty at San Diego State University in 1972 at the age of twenty-three and remained a full-time professor until 2010.

Shirley Weber (1948–present),
founder of Africana studies at SDSU.
Courtesy of California State Assembly.

As one of the original faculty members, she was instrumental for the development of the Africana Department's curriculum and recruitment of faculty and students. During her administration of the department from 1979 to 1985 and 1988 to 1991, it developed a national reputation as one of the strongest undergraduate Africana studies programs in the country. Under Weber's leadership, the Africana Studies Department became, in many ways, a central piece of the cultural life and the activities of students on the campus. It was the link between the larger community, the black student community and the university, ensuring the issues of diversity and equal opportunity were always on the table.

Dr. Weber met her husband, Daniel Weber, when they were both studying at UCLA. At the time, Daniel Weber was studying law and eventually rose to be a California state judge. They married after she moved to San Diego and have two children, Akilah and Akil. Recognizing the importance of close connections in one's life, Weber and her husband became very involved with the community, which was completely different from her home environment in Los Angeles and played a significant part of her life. During her oral history discussion, she remarked, "My God, I've been here over thirty-five years now, and it's not like an overnight experience, or a quick love affair—this is a life-long experience." Knowing and understanding the people of San Diego was critical to her community participation.

The Weber children attended public school, and in 1988, Dr. Weber was elected to the San Diego Unified School District school board. She served two consecutive four-year terms—several of those as president of the board—until she retired in 1996. As a board member and subsequent board president, she successfully advocated for closing the achievement gap and for attaining a higher standard of excellence for all students and a decrease in the dropout rates among high school African American men and Hispanic women. Additionally, the board succeeded in passing an initiative to build new schools in older, overcrowded neighborhoods.

Encouraged by the community, Weber decided to enter politics and run for State Assembly in the Seventy-Ninth District, where she had lived for thirty years. In November 2012, Weber defeated the incumbent and became the first black person south of Los Angeles elected to the California legislature. She was blazing another path and a new career. She understood the historic importance of her election. "I think my winning does open up opportunities for other individuals who may have thought they couldn't run in a lot of districts in San Diego County because the African-American population is too small," she said in a *Union Tribune* article. Weber's goals include helping establish a Cal State University in Chula Vista, reducing student tuition and improving access to higher education.

Reelected by a wide margin in November 2014, Weber is a member of twelve committees and a sponsor so far of several hundred bills. Appointed by Toni Atkins, Speaker of the California House of Representatives, to serve as chair of the Assembly Budget Committee has raised Weber's profile. Other committees she chairs are the Budget Process Oversight and Program Evaluation, Campus Climate, Higher Education in San Diego County and Regional Approaches to Addressing the State's Water Crisis.

Shirley Weber's goals in Sacramento do not include going along to get along. Her focus is similar to what she strived to accomplish as a board of education member, which is to improve the lives and education of the citizens of California, especially those with little opportunity. She is not interested in the spotlight unless it can help her make a difference, she noted in a *Union Tribune* interview.

In any position she has held, Weber was always noticed for her excellent oratory skills, and as a member of the legislature, this still holds true. She is recognized as one of the most articulate speakers. Her colleagues acknowledge that Weber provides Sacramento "the same bold, no-nonsense leadership that she's provided San Diego for decades."

There is more to the accomplishments and contributions of Dr. Weber. In the mid-2000s, she hosted a popular weekly radio program, "It's a New Day with Dr. Shirley Weber," on a San Diego station and internationally over the Internet. When she took some students to Johannesburg, South Africa, the program was aired live, sharing her students' perceptions and those of the South Africans. Dr. Weber lectures widely throughout the United States, Caribbean and Africa.

Humanitarian work is a critical part of what Shirley Weber represents. For this community involvement, Weber has received hundreds of awards and recognition from a diverse number of organizations. She served as the

mayor's appointee and chair on the Citizens' Equal Opportunity Commission and was a member of the boards of the NAACP, YWCA, Battered Women Services, United Way and many other organizations.

Weber's work has touched the lives of thousands of young people throughout the county, and it is her desire to continue serving her community and contribute to enhancing the lives of the residents of California. The African American community is proud of Weber's dynamic skills and the work she has done on its behalf.

LENORE BOHM (1954–present)

Feminist Spiritual Leader

Children dream of becoming someone awesome, of doing something no other person has achieved, maybe even of being superwoman or superman. Too often, they grow up and realize how naïve and imaginary their ideas were. This was not so for Lenore Bohm. When she was fifteen years old, she had a life-changing experience. It was 1969, and she participated in an Atlanta Youth Leadership trip to Israel, where she had the remarkable opportunity to meet personally with Golda Meir and David Ben Gurion. The young Lenore Bohm was so enthralled with the country and the people she decided she wanted to become a rabbi, and her burgeoning commitment to Judaism and Jewish life intensified. At that time, women were not permitted to be ordained as rabbis, so she did not tell anyone about her dream and ambitions.

Bohm was in New York City in 1954 to refugee parents, Trudie and Fred Bohm. Both her parents had fled from Vienna, Austria, in 1938. Her childhood was instilled with Viennese culture: food, music, art and the supremacy of a European education. The family lived an assimilated life, but her parent's Viennese values had a significant impact on her future. References to her parents' and extended family's experiences as Hitler's dominance grew in Austria—as anti-Jewish legislation was enacted and as their homes and businesses were destroyed on Kristallnacht—made an impact on Bohm as a young girl. Although there were few conversations about Judaism per se, Bohm sensed that being part of the Jewish people was important and determines one's choices and opportunities. Very specifically, Rabbi Bohm remembers feeling as if she were a magnet being drawn to the Jewish culture.

Lenore Bohm (1954–present), feminist spiritual leader. *Courtesy of Rabbi Lenore Bohm.*

She attributes this to the harsh realities her parents experienced when leaving their beloved Vienna. Bohm does recall detailed information about her second grade Hebrew school classroom and an early interest in Hebrew letters; she was fascinated with an Israeli girl who became her best friend; and she sensed the difficulties her parents lived through even though their experiences were not openly talked about. The clouds were there.

Her family moved to Atlanta in 1964 and joined a Reform congregation, which at that time did not incorporate Hebrew in its services. As a newcomer to the South, Bohm did not feel she or her family fit in well, but she found a meaningful sense of community through a few different Jewish youth groups. These connections provided the impetus for her taking a teen trip to Israel and a new direction for the future. For four years, she did not reveal her desire to be a rabbi to anyone, including her sister and parents. After she graduated from high school, she started to talk openly about her plan to be a spiritual leader. Hesitant as she was about discussing this, however, she spoke to her rabbi about her future endeavor. His response was, "You do not want to be a rabbi; you want to be a rabbi's wife and president of Sisterhood."

For the next three years, Bohm attended Carnegie Mellon University in Pittsburgh, and after graduation, she applied to the Hebrew Union College to begin her rabbinic studies. Her application was put on hold; she was very young, and they were very selective. Only twenty women were studying there, and they wanted her to do more soul searching to be certain about her choice of career. After looking into several programs, Bohm applied and was accepted to the Interfaith Seminary in Washington, D.C., where she studied with other young aspiring priests, rabbis and ministers. Together they attended classes for a year and were educated in the common needs required of those entering the ministerial professions.

When she reactivated her application to the Hebrew Union College in Cincinnati, Ohio, Bohm was accepted into the program. Ten of the seventy students were women, and Bohm noted that she "felt like a pioneer but not a radical." The next few years of study were a whirlwind of activity. She lived in Israel for fourteen months and interned for three months in Australia in 1980. In 1982, Bohm was one of the first fifty women ordained into the rabbinate. Since female rabbis were a new phenomenon, for some finding employment was easy, as hiring them was viewed as desirable and reflective of how contemporary Reform Judaism was. For most, however, this was not the experience.

Rabbi Bohm's first job was as assistant rabbi at Congregation Beth Israel, one of the oldest Reform synagogues in San Diego, making her

the first female rabbi in San Diego County. She brought to her position a new perspective. Teaching was a passion of hers, and she was constantly searching for different viewpoints and interpretations of the Jewish texts. Her desire to learn, along with her extremely inquisitive mind, was molding Rabbi Bohm to be a unique rabbi with fresh ideas about Judaism, the place of women in Jewish life and feminist spirituality. "I deplore predictability," she said. At Beth Israel, she developed a reputation as an inspiring teacher and a caring rabbi who was beloved by many of her congregants.

Three years later, Rabbi Bohm left Beth Israel to become the senior rabbi at a burgeoning congregation in North San Diego County. Temple Solel was a young synagogue with 40 families when Lenore Bohm began her service there. It was developing its own personality and was drawn to a young rabbi. "I found I could be very creative (at Temple Solel) with services and lifecycle rituals, and I felt very comfortable speaking on the issues of the day from the pulpit," she said in an article in the *San Diego Jewish Journal*. Seven years later, Bohm had helped develop this small temple into one with a membership of 450 families.

Rabbi Bohm was married to Dr. Paul Goodman, and they already had two sons when she began her work at Temple Solel. She wanted more children and believed it was best for her family if she gave up being a full-time spiritual leader. In 1992, she left the temple and eventually gave birth to another son and adopted a three-year-old daughter from a Siberian orphanage. The family continued to remain affiliated with Temple Solel.

Although she was raising four small children, Rabbi Bohm was continually seeking religious and spiritual knowledge and fulfillment. She developed community partnerships and decided to take a graduate program in feminist theology at the Claremont Graduate University in Pomona. Bohm was particularly affected by the writings of two Christian female theologians, which opened a new facet of her faith and challenged her to focus on literary subtleties in the Torah as well as contemporary Jewish writings. When this advanced program concluded, she was offered a six-month position at a synagogue in Adelaide, Australia, the same synagogue she had previously interned with while at the Hebrew Union College. The entire family moved to Australia, and the six months became two years. The synagogue is part of the Progressive movement and is very Israel-oriented with a striking diversity of religious and cultural backgrounds.

Again education beckoned, and from 2004 to 2006, Bohm participated in the innovative Shalem Institute, completing training in contemplative

practice and leading retreats. She then studied in a two-year program, Spiritual Direction, at the University of San Diego from 2007 to 2009. Although the program was taught with an emphasis on Catholic traditions, it trained students to work with people to help them discover the spiritual dimension of their lives. Rabbi Bohm noted that she received a perspective on life that a typical rabbi might not normally receive.

In 2008, Bohm became a strong advocate for Waters of Eden, a transformational project committed to building a *Mikvah*, a dedicated pool of water, which is a part of every Jewish community around the world. Rabbi Bohm was on the board of directors for many years and became executive director in 2013 for two years. Her hope was to have this organization serve as a resource for any change, transition or healing purpose in a person's life.

As she continued to serve the San Diego Jewish community in numerous capacities, the foundation of her work remained constant: "to make Judaism accessible by encouraging and allowing for the multiple interpretations of rituals." Bohm incorporated this philosophy whether she was teaching or carrying out rabbinic or pastoral work. She easily infused spirituality into the environment, whether it was a classroom, the pulpit or a work environment. For Rabbi Bohm, the basic question is always, Is this in keeping with the foundational ideas of Judaism and with Jewish values?

Her involvement has been far-reaching, touching many organizations in San Diego, and includes serving as a board member for the Leichtag Foundation, a founding board member for the Jewish Women's Foundation, a board member of Hillel of San Diego, and rabbi-in-residence at Camp Mountain Chai Women's Weekend. She took part in the March of Living 2000, was past president of the San Diego Rabbinical Association and has participated in the Central Conference of American Rabbis, the Women's Rabbinic Network and many other local, national and international women's and interfaith organizations.

She broke the barriers for all other female rabbis in San Diego not only with her rabbinic and pastoral approach but also through her progressive philosophy and teachings about women, Judaism and feminist and spiritual theological perspectives. What is next for Rabbi Bohm? She is currently living in Israel and recently said, "I am immersing myself in this beloved culture and land and trying to better grasp the blessings and challenges of Jewish identity in the twenty-first century."

SHELLEY ZIMMERMAN (1960–PRESENT)

The Zimmerman Code Enforcer

What exactly is the Zimmerman Code? As San Diego chief of police Shelley Zimmerman explains, it is a philosophy that her late father, Philip, inculcated in her and her three siblings as they were growing up. In an interview in the *San Diego Jewish World*, Zimmerman referred to the "Zimmerman Code," a lifestyle by which the family lived. She noted, "It taught us to support each other and always treat all people at all times with respect." Zimmerman explained they were "always looking out for the little guy, or as my dad would say, 'those who can't look out for themselves, it's up to us to look out for them.'" And this is how Chief Zimmerman runs her department and instructs her officers and staff to conduct themselves each day.

Rising to the position as chief of police had not crossed her radar in the thirty-one years she had served in the San Diego Police Department, where she worked in a variety of assignments and leadership roles. Her style was not to run up the career ladder seeking promotions. Her goal was to perform optimally in any job to which she was assigned. Others, however, recognized her as a talented and well-respected leader in addition to being an exceptional officer and devoted public servant. In March 2014, at the age of fifty-four, she was selected to replace Chief of Police William Lansdowne and became the first female chief of police in San Diego.

Zimmerman grew up in a tightknit family in Beachwood, Ohio, a suburb of Cleveland, with her two brothers and a sister, all very accomplished in their professions. Her father, Philip, a trial attorney, and her mother, Elaine, a devoted homemaker, provided a secure home instilled with values to look after themselves and their community. Her parents emphasized the importance of education and of following the "Code." As a youngster, Zimmerman developed an interest in police work and was either reading Joseph Wambaugh's novels or watching crime shows on TV. A police scanner was a permanent fixture in her room, and she and her siblings would listen at night for reports of crime in their town. Another major focus as she was growing up was sports. In high school, Zimmerman was captain of the girls' basketball team, marched in the band and ran track. An unabashed Ohio Buckeye fanatic, her office is decorated in team regalia, and whenever possible, she travels to Ohio State games.

Sports brought her to California when she and some friends decided to go to the Rose Bowl to see Ohio State play USC. They then visited San Diego, and

Shelley Zimmerman (1960–present), the Zimmerman Code enforcer. *Courtesy of the San Diego Police Department.*

Zimmerman, taken by the beauty of the city, decided she would be returning. After finishing her degree in criminal justice, she packed her bags and came back to San Diego planning to attend law school. While saving money for school, she worked odd jobs. An advertisement to join the San Diego Police Academy caught her eye, and she applied. Zimmerman intended to work as a law enforcement officer and go to law school at night. Her plans took a different direction, however, and decades later, she is the chief.

Zimmerman is devoted to the department and has never had an assignment she disliked. Starting as a beat cop, she rose through the ranks. Some of her assignments have included serving as chauffeur to former mayor Maureen O'Connor, going undercover as a fifteen-year-old student at a local high school (where she cracked an infamous student narcotic ring) and posing as a prostitute. She worked in internal affairs and multicultural relations and undertook many other crime investigations and administrative positions. Serving the community and connecting with the residents was one of her major tenets of policing. As a beat cop, Zimmerman was known for being available to community groups and organizations; she was well liked and respected in the neighborhoods where she worked. Within the department, she was recognized as a team player who never sought center stage and preferred to remain out of the spotlight.

During her years of service, her superiors urged her to take the exams so she could move through the ranks, which she did, from sergeant to lieutenant and from captain to assistant chief. When questioned about gender discrimination within the department, Zimmerman said she never felt there was a glass ceiling or any bias against women. For anyone in the department, the opportunities are endless, and if you worked hard and did your job, you succeeded.

Zimmerman enjoys widespread support on the city council and was unanimously appointed. The department, however, had some serious challenges Zimmerman had to address immediately. Sexual misconduct, racial profiling and the ongoing struggle to recruit, retain and motivate officers in a city with long-standing fiscal woes were just a few of the issues facing the new chief. One of her priorities was to convince the public that the department did not condone racial profiling. "It doesn't matter what I think," she said. "It's what the community thinks that counts," she noted in a *Los Angeles Times* interview.

Many in the community believed there was a lack of transparency and community interaction by upper-level administration. Zimmerman approached these issues straight on and vowed not to tolerate officer

misconduct. She reestablished the professional-standards unit to watch for signs of potential misconduct among officers and has proclaimed a policy mandating an officer to file a report when a colleague witnessed misconduct. With the support of the mayor and city council, the department also now requires officers to wear body cameras. San Diego is a national leader in the body camera movement, and Zimmerman attests it is a "win-win situation for officers and the public's trust." After cameras were instituted, officers reported a de-escalation in civilian aggressiveness.

Among Chief Zimmerman's stated priorities is to ensure the San Diego police live up to their designation as "America's Finest" so that the city's residents feel safe in their communities. Immediately after her appointment as chief, Zimmerman started to hold meetings for the city's 123 communities to send an unambiguous message that officers would do all they can to build community trust in them and unlawful activities among a few officers would not be permitted. "We're instilling a culture of excellence, demanding it of ourselves, and it is what the community deserves," Zimmerman said at one of her many community appearances. "It takes years to build trust in the community and just a few minutes to lose it."

Trying to keep up with Shelley Zimmerman is a daunting task, as she moves quickly and is constantly meeting in one of the more than one hundred patrol areas or attending one of numerous community groups. Her objective is to meet as fast as possible with as many groups as possible, and for her to give out her cellphone number is not uncommon.

The chief's passion for sports is with her daily, and she communicates with her officers and staff in sports analogies, viewing herself as the head coach. She tells them, "If you intentionally fumble the ball or throw an interception, you're out. If you didn't mean to…you can still play, but you'll do a bunch of wind sprints [re-training]."

Chief Zimmerman has been the recipient of numerous awards and citations throughout her career. These include the San Diego Press Club Headliner of the year award for her undercover work, the *San Diego Business Journal*'s Women Who Mean Business Exemplary Award for her civic involvement with both the business and residential communities, the San Diego Police Foundation Women in Blue Award for her commitment to making San Diego one of the safest large cities in the United States and the Gold Key Award from the Hotel/Motel Association for her commitment to the hospitality and tourism industry.

In the short time she has been chief of police, Zimmerman has made great progress in gaining the trust of the residents of San Diego and has

proven she understands the needs of the community, cares deeply about the neighborhoods and is devoted to the police department. It all can be traced back to the "Zimmerman Code."

TONI ATKINS (1962–PRESENT)

Appalachia to San Diego

To progress from living in an impoverished area of Appalachia to being Speaker of the Assembly of the California state legislature is an unusual journey for a woman to take. However, for Toni Atkins, a believer in collaboration and coalition building, this path was a natural one. In her position as Speaker, she achieves two "firsts." She is the first lawmaker from San Diego and the first lesbian to hold the title. At her swearing-in ceremony, many of her fellow legislators acknowledged her disadvantaged background and commended her on achieving what she has accomplished in her life.

Her selection to lead the Sixty-Ninth Assembly District was significant both for the state legislature and the LGBT community. The unanimous bipartisan vote acknowledged the respect her colleagues have for her open-mindedness. She speaks openly about being gay, and she reinforces her honest words with authentic actions. At a SheShares women's leadership conference, she told the attendees, "The most profound way of advancing equality is coming out and taking small actions that validate being gay." She demonstrated this by openly kissing her spouse, Jennifer LeSar, at her inauguration as Speaker.

Atkins was born in Wyethe County in southwest Appalachia. The daughter of a miner and a seamstress, she and her twin grew up in a home that had no running water. As a twin, Atkins has always been part of a team. "I'm a twin. I've always been a 'we, not me.'" Thus, her collaborative style of working with others to solve mutual problems stems from her childhood. She prefers, "Let's figure out how we can do this together."

Atkins earned her bachelor of science in political science/community organizing from Emory and Henry College and graduated from the Senior Executive Program at the John F. Kennedy School of Government of Harvard University in 2004. The start of her career in public service began in the mid-1980s, when she served as director of clinic services at Womancare Health Center in San Diego. She became a staff representative for San Diego city councilmember Christine Kehoe of

Toni Atkins (1962–present), member of the California Assembly. *Courtesy of Assembly Democratic Caucus.*

District 3, later winning her mentor's council seat after Kehoe's election to the Assembly.

Atkins served two terms on the San Diego City Council, from 2000 to 2008, representing District 3. She was lauded as a leader in the areas of affordable housing, workers' rights and neighborhood services and revitalization. Motivated by her roots growing up in a house without running water or a bathroom and a family that lacked health insurance, Atkins identified homelessness, affordable housing and healthcare as priorities, which she has carried through as a representative and leader of the California legislature. Working to bring more visibility to these priorities, she also guided the development of the city's first inclusionary housing policy and led the council

to approve a Living Wage Ordinance. One of her noteworthy successes on behalf of the LGBT community was her work to influence the city council and the mayor to add the City of San Diego to a friend-of-the-court brief in support of marriage equality in 2007.

During her tenure on the council, Atkins represented the City of San Diego in the local chapter of the League of California Cities, on the board of the Metropolitan Transit System, in the San Diego Association of Governments, in the Regional Housing Working Group and in the San Diego River Conservancy.

Her assembly district covers the coastal region of San Diego, from Imperial Beach along the Mexican border to Solana Beach, encompassing most of central San Diego. Speaker Atkins is a coalition builder who believes government policies can improve people's lives. During her terms on the council, she was widely recognized as a leading voice for affordable housing, a powerful advocate for women and a champion for veterans and homeless people.

Atkins is a supporter of the family and strongly believes that family is integral to everything. "It's the core of what we believe in life and work for in life," she noted in an article on the WomanCanBuild website. In an interview in the *Union Tribune*, Atkins vividly remembers being belittled for being poor, victimized for acknowledging she was a lesbian and provoked by seeing her much-loved mountains stripped for their coal—imparting in her a compassion for the less-fortunate, the different and the environment.

She has brought steadiness and civility to the legislature's lower house by managing the needs and personalities of the eighty-member Democrat-controlled chamber with a direct but not heavy-handed style, as acknowledged by her colleagues on both sides of the legislature. Her philosophy of governing through collaboration has freed lawmakers to focus on the state's high-priority and urgent issues rather than political competitiveness. "She leads from a place of fairness and wants to bring as many people together as possible," said Assembly Republican leader Kristin Olsen of Modesto.

Although her focus is to work as a team, this leadership technique sometimes runs counter to Atkins's duty to decide which lawmakers will move up in the power structure of the Assembly. She is solely responsible for deciding the committee chair assignments or even just approving a larger office space. "If I'm learning anything, there's a reason a speaker feels lonely. It's a lonely place to be because ultimately you really are responsible for how things happen," Atkins said.

Named in her honor, the Toni Atkins Lesbian Health Fund was established by the Imperial Court de San Diego in conjunction with the San Diego Lesbian, Gay, Bisexual, Transgender Community Center to assist low-income lesbian and bisexual women in need of medical treatment, referrals, support, education, advocacy and guidance through the healthcare system. Atkins has been active in both the LGBT and women's communities since 1987 and worked with the center's Lesbian Health Project to implement the first Lesbian Health Fair in 1991 as part of the LGBT Pride Festival. She was recognized in 1997 as San Diego Pride's Woman of the Year. She will always work for full equality for gays and lesbians and noted recently, "We don't have full equality," Atkins said. "Even in California, there are places and towns…that I probably wouldn't feel very comfortable taking Jennifer's hand."

As Atkins handed the gavel to the new Speaker of the Assembly and moved out of the state legislature under the current term limits, she said, "This has been an incredible ride.…I'm a kid from Appalachia who grew up in a house with no running water. [Now] I get to negotiate with the most iconic governor in the United States."

She has received dozens of awards for her work both in and out of office, including the Coastal Champion Award by San Diego Coastkeeper, the Historic Preservation Award from the American Institute of Architects and the San Diego Democratic Club's Doug Scott Award for Political Action.

Atkins has a bright future in politics or whatever she envisions for herself. Her focus on life is to continue to help the less fortunate and achieve what she sought for herself as she moved from Appalachia to Speaker of the California Assembly. Atkins is an exemplary role model as a remarkable woman who moved from poverty to power.

BIBLIOGRAPHY

Part 1: 1850–1900

Carnes, Marilyn, and Matthew Nye. *Early National City.* Mount Pleasant, SC: Arcadia Publishing, 2008.

"Charlotte Baker M.D." Women's Museum of California. http://womensmuseumca.org/hall-of-fame/charlotte-baker-md.

Crawford, Richard. "First Library Building Quickly Outgrew Its Space." *San Diego Union Tribune*, May 24, 2008.

"Death of Mrs. Flora M. Kimball." California Digital Newspaper collection. http://cdnc.ucr.edu/cgi-bin/cdnc?a=d&d=PRP18980723.2.20.7.

Engstrand, Iris. *San Diego: California's Cornerstone*. San Diego, CA: Sunbelt Publications, 2005.

"Father Antonio D. Ubach (unknown–1907)." San Diego History Center. http://www.sandiegohistory.org/"www.sandiegohistory.org/bio/ubach.htm.

Harrison, Donald H. "San Diego's Historic Places: Mason Street School." Sdiegojewishworld.wordpress.com/2010/05/sam-diegos-historic-places-mason-street-school/

Hoiberg, Anne. "Woman's Suffrage: A Victory for San Diego." *San Diego Union Tribune*, October 7, 2011.

"Kate Sessions." Women's Museum of California. http://womensmuseumca.org/hall-of-fame/kate-sessions.

"Kate Sessions (1857–1940)." San Diego History Center. http://www.sandiegohistory.org/bio/sessions/sessions.htm.

Kneeland, Marilyn. "The Modern Boston Tea Party the San Diego Suffrage Campaign of 1911." *Journal of San Diego History* 23, no. 4 (Fall 1977).

MacPhail, Elizabeth. *Kate Sessions Pioneer Horticulturist.* San Diego, CA: San Diego Historical Society, 1976.

————. "Lydia Knapp Horton: A Liberated Woman." *Journal of San Diego History* 27, no.1 (Winter 1981).

"Mary Chase Walker (1828–1899)." San Diego History Center. www.sandiegohistory.org/journal/73spring/walker.htm.

Mathes, Valerie Sherer. "Afterword." In *Ramona.* New York: New American Library, 2002.

————. *Helen Hunt Jackson and Her Indian Reform Legacy.* Norman: University of Oklahoma Press, 1997.

Nye, Matthew. "A Life Remembered: The Voice and Passions of Feminist Writer and Community Activist Flora Kimball." *California History* 87, no. 4 (September 2010).

"Olivewood Women's Club." Save Our Heritage Organization. http://www.sohosandiego.org/endangered/mel2008/olivewood.htm.

Robens, Alma Kathryn. "Charlotte Baker: First Woman Physician and Community Leader in Turn of Nineteenth-Century San Diego." Master's thesis, San Diego State University, 1992.

San Diego Union Tribune. "Kate Sessions 'Mother of Balboa Park.'" May 8, 2015.

Schwartz, Henry. "The Mary Walker Incident: Black Prejudice in San Diego, 1866." *Journal of San Diego History*, no. 2 (Spring 1973).

Simonson, Albert. "Mary Chase Walker: Our Gumption Girl." www.alpinehistory.org/mary_chase_walker.html.

Smythe, William E. *History of San Diego, 1542–1908.* San Diego, CA: History Company, 1908.

Valnzuela, Romualdo. "Helen Hunt Jackson." The Historical Society of Southern California. www.socalhistory.org/biographies/helen-hunt-jackson.html.

"Women's Activities." California State Grange. http://www.californiagrange.org/gwa/.

"Women's Voluntary Associations: The Wednesday Club." The History of Books. https://historyofbooks.wordpress.com/san-diego-the-exempler-of-the-american-free-public-library-movement.

Part 2: 1900–1950

Allabeck, Sarah. *The First American Women Architects*. Chicago: University of Illinois Press, 2008.

"Belle Benchley and the Creation of the Modern Zoo." http://madartlab.com/bellebenchley/.

"Belle Jennings Benchley (1882–1972)." San Diego History Center. https://www.sandiegohistory.org/online_resources/benchley.html.

"Belle Jennings Benchley (1882–1972): Find a Grave Memorial." http://www.findagrave.com/cgi-bin/fg.cgi?page=gr&GRid=8365.

Boaz, Martha. *Fervent and Full of Gifts: The Life of Althea Warren*. New York: Scarecrow Press, 1961.

Breed, Clara E. *Turning the Pages: San Diego Public Library History 1882–1982*. San Diego, CA: Friends of the San Diego Public Library.

"California Library Hall of Fame: Althea Warren (1886–1958)." http://www.cla-net.org/?page=669.

Carlson, Dick. "Women in San Diego: A History in Photographs." *Journal of San Diego History*, no. 3 (Summer 1978).

Crawford, Richard. "First Library Building Quickly Outgrew Its Space." *San Diego Union Tribune*, May 24, 2008.

———. *The Way We Were in San Diego*. Charleston, SC: The History Press, 2011.

Daly-Lipe, Patricia, and Barbara Dawson. *La Jolla a Celebration of Its Past*. San Diego, CA: Sunbelt Publications, 2002.

Day, Deborah. "Ellen Browning Scripps Biography." Scripps Institution of Oceanography Archives. scilib.ucsd.edu/sio/biogr/Scripps-Ellen-Biogr.pdf.

"Ellen Browning Scripps (1836–1932)." San Diego History Center. http://www.sandiegohistory.org/bio/scripps/ebscripps.htm.

"Ellen Browning Scripps Founder of Scripps Memorial Hospital and Scripps Metabolic Clinic in La Jolla." http://www.scripps.org/about-us_who-we-are_history_ellen-browning-scripps.

"Estudillo House San Diego, California." American Latino Heritage. http://www.nps.gov/nr/travel/american_latino_heritage/Estudillo_House.html.

Fogel, Gary. *Wind and Wings: The History of Soaring in San Diego*. San Diego, CA: Rock Reef Publishing House, 2000.

Hahn, Emily. *Eve and the Apes*. New York: Ballantine Books, 1988.

"Hazel Wood Waterman Collection 1902–1945." San Diego: San Diego History Center. https://www.sandiegohistory.org/MS%2042.

"History of the University of San Diego." University of San Diego. https://www.sandiego.edu/about/history.php.

"Hon. Madge Bradley." San Diego County Bar Association. https://www.sdcba.org/index.cfm?pg=CriminalJusticeMemorial#bradley.

Kelly, Kate. "Luisa Moreno (1907–1992), Labor Organizer." America Comes Alive. http://americacomesalive.com/2013/09/01/luisa-moreno-1907-1992-labor-organizer/#. VNKqzp3F9VZ.

Klem, Monica. "Ellen Browning Scripps." Philanthropy Hall of Fame. http://www.philanthropyroundtable.org/almanac/hall_of_fame/ellen_browning_scripps.

Larralde, Carlos, and Richard Griswold de Castillo. "Luisa Moreno and the Beginnings of the Mexican American Civil Rights Movement in San Diego." *Journal of San Diego History* 43, no. 3 (Summer 1997).

"Madge Bradley: Pioneering Female Judge." *Los Angeles Times*, March 24, 2000. http://articles.latimes.com/2000/mar/24/news/mn-12294.

"Madge Bradley: 2002 Trailblazer." Women's Museum of California. http://womensmuseumca.org/hall-of-fame/Madge-bradley.

Manning, Molly G. *When Books Went to War*. New York: Houghton Mifflin Harcourt, 2014.

McHugh, Helen. *Founder's Tale: Mother Rosalie Clifton Hill and the Founding of the University of San Diego*. San Diego, CA: University of San Diego, 2005.

———. "Mother Rosalie Hill, RSCJ, and the Chicago Connection." https://www.shschicago.org/.../Mother-Hill.

"No Lake Landings." *Time*, September 29, 1930. http://content.time.com/time/magazine/article/0,9171,740428-4,00.html.

Poynter, Margaret. *The Zoo Lady Belle Benchley and the San Diego Zoo*. Minneapolis: Dillon Press, 1980.

Ruiz, Vicki L. *From Out of the Shadows: Mexican Women in Twentieth Century America*. New York: Oxford University Press, 2008.

"Ruth Alexander." Women in Aviation webzine. http://youflygirl.blogspot.com/2008/11/ruth-alexander.html.

Scher, Laura. "Madge Bradley: San Diego's First Female Judge." Women's Legal History website.Wlh.law.stanford.edu/biography-search/.

Scott, Mary. *San Diego: Air Capital of the West*. San Diego, CA: San Diego Aerospace Museum, 1991.

Thornton, Sally Bullard. *Daring to Dream: The Life of Hazel Wood Waterman*. San Diego, CA: San Diego Historical Society, 1987.

"USD President Wraps Up Tenure, Marks Achievements." *San Diego Union Tribune*, May 21, 2015.

"Who Was Luisa Moreno?" San Diego Mexican & Chicano History. http://aztlan.sdsu.edu/chicanohistory/chapter08/c08s01.html.

Part 3: 1950–2000

"Alcohol Addiction Survivor Jeanne McAlister Is Today's Honoree." Today's Honoree. October 2, 2012. https://todayshonoree.wordpress.com/2012/10/02/alcohol-addiction-survivor-jeanne-mcalister-is-todays-honoree.

"Anna Sandoval Historian." Women's Museum of California: Hall of Fame Inductee 2010. http://womensmuseumca.org/hall-of-fame/anna-sandoval.

"Anna Sandoval Obituary and Picture." Kumeyaay.info. http://www.kumeyaay.info/whoswho/inmemory/anna_sandoval.html.

Bell, Diane. "Diane Bell Talks to Martha Longenecker." *San Diego Union Tribune*, May 9, 2010.

Blair, Tom. "Deborah Szekely: A Dialogue with Tom Blair." *San Diego* magazine, March 24, 2009.

"Building a Future by Honoring the Past." Sycuantribe.org. http://sycuantribe.org/2013/12/05/building-a-future-by-honoring-the-past/. December 5, 2013.

"Chadwick, Florence May." Encylopedia.com. http://www.encyclopedia.com/topic/Florence_May_Chadwick.aspx.

Edelson, Paula. *A to Z of American Women in Sports*. New York: Infobase Publishing, 2002.

"Educational Organization: Women in Administrative Position; The Glass Ceiling." Regent University. https://www.regent.edu/acad/schedu/pdfs/residency/glass_ceiling.pdf.

Fidlin, Dave. "57 Years…and Counting!" *San Diego Downtown News*, June 6, 2014.

Fisher, Alan. "A Tribute to Deborah Szekely." *Huffington Post*, May 3, 2012.

"Florence Chadwick 1953–1964." Queen of the Channel. http://www.queenofthechannel.com/florence-chadwick.

Garin, Nina. "Four Decades Helping Others Get Sober." *San Diego Union Tribune*, April 3, 2013.

Gree, Emma. "Meet Deborah Szekely, a 91-Year-Old Wellness Warrior." *The Atlantic*, October 5, 2013.

Hanson, Ann Aubrey. "To Rome for a Friend: Dr. Anita Figueredo and Mother Teresa." *Southern Cross*, April 2004.

"History of the Mingei." Mingei International Museum. http://www.mingei.org/about/history-of-mingei/.

"Joan Kroc." California Museum. http://www.californiamuseum.org/inductee/joan-kroc.

"Joan Kroc, Unconventional Philanthropist." Legacy.com. http://www.legacy.com/news/legends-and-legacies/joan-kroc-unconventional-philanthropist/1567/.

"Joan Kroc: Cultural Competent Bridge Builder." Women's Museum of California: Hall of Fame Inductee 2004. http://womensmuseumca.org/hall-of-fame/joan-kroc.

Kelsey, Cheryl, Kathy Allen, Kelly Coke and Glenda Ballard. "Lean In and Lift Up: Female Superintendents Share Their Career Path Choices." *Journal of Case Studies in Education* 7 (December 2014).

Lewis, Fred. "The Heart of San Diego-Interview." https://www.youtube.com/watch?v=lH5QQVK0LGg. 1999.

Lieberman, Paul. "Tribe Hits Jackpot with Its Gambling Operation: Indians: Led by Welfare Mother, Clan Members Take Back Business from Outsiders and Transform Their Lives." *Los Angeles Times*, October 8, 1991.

Manna, Marcia. "Anita Figueredo." *San Diego* magazine, November 8, 2009.

"Martha Longenecker: Historian." Women's Museum of California: Hall of Fame Inductee 2011. http://womensmuseumca.org/hall-of-fame/martha-longenecker.

"Martha Longenecker Professor and Advocate for Art." California State University. http://www.calstate.edu/honorarydegrees/2007/bio-longenecker.shtml.

Maugh, Thomas, II. "Dr. Anita Figueredo Dies at 93; First Female Surgeon in San Diego." *L.A. Times*, March 8, 2010.

McAlister, Jeanne. "Changing the Conversation Addiction." *Times of San Diego*, June 18, 2014. http://timesofsandiego.com/opinion/2014/06/18/changing-conversation-addiction/.

"Mingei International Museum Founder Martha Longenecker Has Died." KPBS Broadcast http://www.kpbs.org/news/2013/oct/30/mingei-international-museum-founder-martha-longene/.

Montgomery, David. "McDonald's Heiress Joan Kroc Super-Sized Her Philanthropy." *Washington Post*, March 21, 2004.

Perry, Tony. "Accord Ends Teachers Strike." *Los Angeles Times*, February 9, 1996.

———. "Philanthropy That Was Deeply Personal." *Los Angeles Times*, January 31, 2004.

Potter, Matt. "Married Rich." *San Diego Reader*, May 31, 2001.

Rafferty, Miriam. "Sandoval Helped Lead Tribe from Poverty to Prosperity." *East County Magazine*, November 2010.

Rancho La Puerta. "Heritage." http://www.rancholapuerta.com/about-the-ranch/vision/heritage/.

"Remarkable Leaders in Education: Bertha Pendleton." https://www.sandiego.edu/news/press-releases.php?_focus=2102.

Richardson, Joanne. "San Diego's Bertha Pendleton Climbs to the Top." *Education Magazine*, December 1, 1993.

Sainz, Pablo. "Latinas Are 'an Inspiration' for the Community." *La Prensa San Diego*, March 13, 2015.

San Diego Grantmakers. "Deborah Szekely San Diego's Iconic Wellness Warrior." https://www.youtube.com/watch?v=TL6WXjGO2GQ.

Spearnak, Catherine M. "A Lifetime of Healing Sick, Helping Poor." *Los Angeles Times*, July 8, 1988.

Szekely, Deborah. "Waiter There's a Guinea Pig in My Soup." *New York Times*, February 10, 2004.

Ware, Susan. *Notable American Women: A Biographical Dictionary Completing the Twentieth Century.* Cambridge, MA: Harvard University Press, 2004.

Waxler, Barry. "Close Up on San Diego Business Welcomes and Featured McAlister Institute." *San Diego Business*, June 23, 2015. https://www.youtube.com/watch?v=BRPSpcrMa3o.

Part 4: 2000–2015

Associated Press. "Nominee Would Be San Diego's First Female Top Cop." *Washington Times*, February 26, 2014. http://www.washingtontimes.com/news/2014/feb/26/nominee-would-be-san-diegos-first-female-top-cop/.

Berman, Alanna. "The First Lady." *San Diego Jewish Journal*, April 27, 2012.

Bohm, Lenore. "Creating Opportunities for Spiritual Awareness and Growth Within a Jewish Family Service." *Journal of Jewish Communal Service* 82, no. 1–2 (Winter–Spring 2007).

———. "Why Water? In the Beginning…" San Dieguito Interfaith Ministerial Association. http://www.sdima.org/friends-in-interfaith.html.

"CFA Member & Professor Shirley Weber to Chair Assembly Budget Committee." California Faculty Association. http://www.calfac.org/headline/cfa-member-professor-shirley-weber-chair-assembly-budget-committee.

Clark, Christine. "White House Names UC San Diego Chancellor Marye Anne Fox National Medal of Science Recipient." UC–San Diego News Center. http://ucsdnews.ucsd.edu/archive/newsrel/awards/10-15chancellorsmedal.asp.

Cohen, Hannah "Interview with Lenore Bohm." May 13, 2015.

Dr. Shirley Weber 79th District State Assembly. http://weberforassembly.ngpvanhost.com/about.

Fox, Marye Anne. "Dear UC San Diego Campus Community." UC–San Diego. http://www.mafox.ucsd.edu/letter/.

———. "I Am Very Blessed to Have People Who Care About Me and About My Career." Chemical Heritage Foundation. Video. http://www.chemheritage.org/discover/online-resources/stories-from-the-field/marye-anne-fox.aspx.

Garcia, Monica. "Atkins: Growing into Leadership." *San Diego Union Tribune*, January 26, 2014.

Harrison, Don. "New Police Chief Lives by 'the Zimmerman Code.'" *San Diego Jewish Journal*, April 10, 2014.

Jacobs, Natalie. "The Accomplishments of a Lifetime." *San Diego Jewish Journal*, May 1, 2015.

La Jolla Light Staff. "California Women Lawyers Salute Lynn Schenk." *La Jolla Light*, September 5, 2014.

"Lynn Schenk: Trailblazer." Women's Museum of California: Hall of Fame Inductee 2012. http://womensmuseumca.org/hall-of-fame/lynn-schenk.

Margoni, Laura. "A Foundation for the Future: UC San Diego Celebrates 50 Years of Achieving the Extraordinary." This Week @ UCSD. http://ucsdnews.ucsd.edu/archive/thisweek/2011/06/13_50years.asp.

Marye Anne Fox Resume. UC–San Diego. http://mafox.ucsd.edu/docs/Marye%20Anne_Fox_curriculum_vitae-July_2011.pdf.

Mason, Melanie. "Assemblywoman Toni Atkins Voted in as Speaker-Elect." *Los Angeles Times*, March 17, 2014.

McIntyre, Michael K. "Beachwood's Shelley Zimmerman Is Now Police Chief of San Diego…" Cleveland.com http://www.cleveland.com/tipoff/index.ssf/2014/05/beachwoods_shelley_zimmerman_i.html.

"New Police Chief Confirmed but Not Without Controversy." CBS8.com. http://www.cbs8.com/story/24879402/aclu-raises-concerns-over-quick-police-chief-choice.

Nichols, Chris. "Weber Challenges Status Quo." *San Diego Union Tribune*, May 25, 2015.

Perry, Tony. "San Diego Police Chief Gives Public a Role in Her Reform Strategy." *Los Angeles Times*, January 8, 2015.

"Presenter Biographies: Lenore Bohm." Camp Mountain Chai. http://campmountainhigh.org/pdf/Womens_Weekend_Bios.pdf.

Resnik, Susan. Interview with Shirley Weber by Susan Reznik. UC–San Diego. http://mafox.ucsd.edu/docs/Marye%20Anne_Fox_curriculum_vitae-July_2011.pdf.

Robbins, Gary, and Steve Schmidt. "Fox's UCSD Tenure Has Trials, Triumphs." *San Diego Union Tribune*, July 5, 2011.

San Diego County Bar Association. Video. https://www.sdcba.org/index.cfm?pg=PublicVideoGallery.

Schenk, Lynn. History, Arts, and Archives: United States House of Representatives. http://history.house.gov/People/Listing/S/SCHENK,-Lynn-%28S000119%29/#biography.

"She Shares with the Honorable Toni Atkins, Speaker of the California State Assembly." California Channel. http://www.calchannel.com/she-shares-with-the-honorable-toni-atkins-speaker-of-the-california-state-assembly/.

"Shirley Nash Weber, PhD." Women's International Center. http://www.wic.org/bio/sweber.htm.

Toni Atkins. "Toni G. Atkins Is the Speaker of the California Assembly. Representing San Diego, CA." http://www.womencanbuild.org/sample-page/articles/toni-atkins.

Walker, Mary. "Shirley Weber Forges Path with Historic Win." *San Diego Union Tribune*, Nov. 18, 2012.

Wilkens, John. "New SDPD Chief Optimistic, Driven," *San Diego Union Tribune*, March 1, 2014.

Nichols, Chris. "Atkins Seen as a Steady Influence as Speaker." *San Diego Union Tribune*, June 15, 2015.

White, Jeremy. "It's Official: Toni Atkins Elected Speaker of California Assembly." *Sacramento Bee*. http://blogs.sacbee.com/capitolalertlatest/2014/03/its-official-toni-atkins-elected-speaker.html.

INDEX

ABOUT THE AUTHORS

HANNAH COHEN

Hannah Cohen has a master of science degree in library and information sciences and an advanced diploma in educational administration. Early in her career, she worked in the public library system in New York and was then director of communications and media, in which role she was responsible for the development of library media centers in a large public school system.

For most of her career, Cohen worked as a public affairs consultant for numerous nonprofit organizations, assisting in capacity building and fund development and advocating for policy changes for the underserved. She worked closely with business and government officials to develop policy and legislation.

Cohen has been deeply involved in advocating for women's equality and the rights of the underprivileged, and she serves on numerous boards promoting awareness of these issues. She is currently president of the Women's Museum of California. Another issue of supreme importance to her is the State of Israel. Cohen is co-coordinator of J Street San Diego, part of the national J Street organization promoting peace in Israel.

GLORIA HARRIS

Dr. Gloria G. Harris began her career as a clinical psychologist in the early seventies after receiving her doctorate from the University of Washington. She coauthored the groundbreaking book *Assertive Training for Women* (1975) and taught assertiveness training and management training for women in federal agencies throughout the United States. She also edited a textbook, *The Group Treatment of Human Problems* (1977), and coauthored a self-help book, *Surviving Infidelity* (1994; 2005), that has sold more than 200,000 copies. Dr. Harris and Hannah Cohen recently coauthored *Women Trailblazers of California* (2012), the stories of forty remarkable women who have been at the core of change and innovation throughout California's history.

Dr. Harris has been appointed to numerous boards and commissions and previously served as chair of the San Diego County Commission on the Status of Women and the County Mental Health Board. She is a former board member of the Women's Museum of California and has been inducted into the San Diego Women's Hall of Fame.